Perspective Depth & Distance

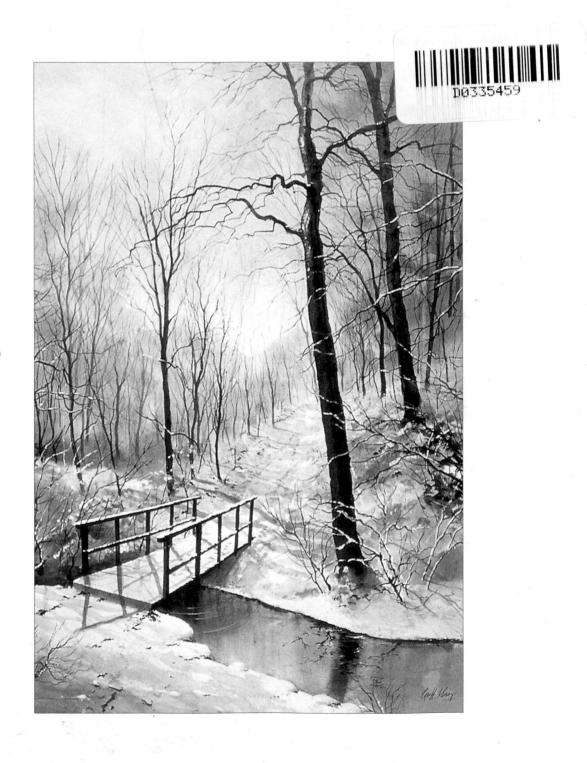

Perspective Depth & Distance

GEOFF KERSEY

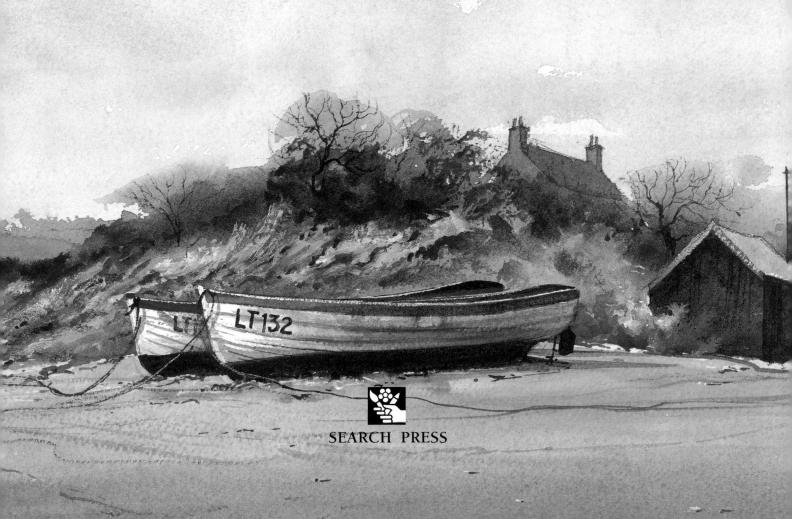

First published in Great Britain 2004

Search Press Limited Wellwood, North Farm Road, Tunbridge Wells, Kent TN2 3DR

Text copyright © Geoff Kersey 2004

Photographs by Charlotte de la Bédoyère, Search Press Studios

Photographs and design copyright © Search Press Ltd. 2004

All rights reserved. No part of this book, text, photographs or illustrations may be reproduced or transmitted in any form or by any means by print, photoprint, microfilm, microfiche, photocopier, internet or in any way known or as yet unknown, or stored in a retrieval system, without written permission obtained beforehand from Search Press.

ISBN 1844480143

The Publishers and author can accept no responsibility for any consequences arising from the information, advice or instructions given in this publication.

Suppliers

If you have difficulty in obtaining any of the materials and equipment mentioned in this book, please visit the Search Press website for details of suppliers: www.searchpress.com

Alternatively, you can write to the Publishers at the address above, for a current list of stockists, including firms which operate a mail-order service; or you can write to Winsor & Newton, requesting a list of distributers.

Winsor & Newton, UK Marketing Whitefriars Avenue, Harrow, Middlesex, HA3 5RH

Publishers' note

All the step-by-step photographs in this book feature the author, Geoff Kersey, demonstrating how to paint in watercolour. No models have been used.

There are references to an animal hair brush in this book. It is the publishers' custom to recommend synthetic materials as substitutes for animal products wherever possible. There is now a large range of brushes available made from artificial fibres, and they are satisfactory substitutes for those made from natural fibres.

Printed in Malaysia by Times Offset (M) Sdn Bhd Colour Separation by Universal Graphics, Singapore

		BOROUGH ENWICH	
38028016485937			
	Browns Books	15/09/04	
	751.422	9.99	
	FL		

Front cover

Halldale Woods in Winter

420 x 292mm (16½ x 11½in)

I love to go walking after a fall of snow: it can transform a scene you might not otherwise see as a potential painting subject. This path leads into a woodland just ten minutes' walk from my home in Derbyshire and has provided me with endless subjects right on my doorstep. Note how, despite this being a winter scene, it doesn't make you feel cold because of the warm glow in the shadows and in the light on the trees.

Page 1 Foot Bridge in the Woods

530 x 750mm (21 x 29³/₄in)

Just further along the same path is this little foot bridge at a junction of paths. Again the snow provides the winter cloak that helps to simplify the scene. I have used a hint of cadmium red and Indian yellow to create that warm glow beyond the trees. The portrait format is ideal for this scene as it emphasises the height of the trees and gives the feeling of a big space.

Pages 2–3 Dunwich Beach

610 x 394mm (24 x 15½in)

I love to paint this type of scene, so typical of the Norfolk and Suffolk coasts, where the landscape is dominated by huge skies. Note how a second glaze was used after the first one had dried, leaving a small area in the top third where the viewer glimpses a patch of light. The small cliffs, old hut and beached boats lend just enough interest without making the scene too cluttered.

Opposite Bluebell Wood

432 x 280mm (17 x 11in)

Unusually for me, this scene has not even a glimpse of sky—instead the mass of greenery encourages the viewer to focus on the carpet of bluebells, created using a mixture of cobalt blue and cobalt violet. Note how the positioning of the trees uses linear perspective to lead the viewer from the foreground to the stile. This then becomes the focal point, positioned roughly a third in from the right and a third up from the base of the scene, a good position from a compositional point of view.

Contents

INTRODUCTION	6	HOLMFIRTH	30
MATERIALS	8	SNOW SCENE	42
DRAWING AND SKETCHING	12	GLENCOE	52
USING COLOUR	14	BOATS AT BOSHAM QUAY	62
LINEAR PERSPECTIVE	18	CROMFORD CANAL	72
AERIAL PERSPECTIVE	22	FARM BUILDINGS	84
SKIES	24	INDEX	96

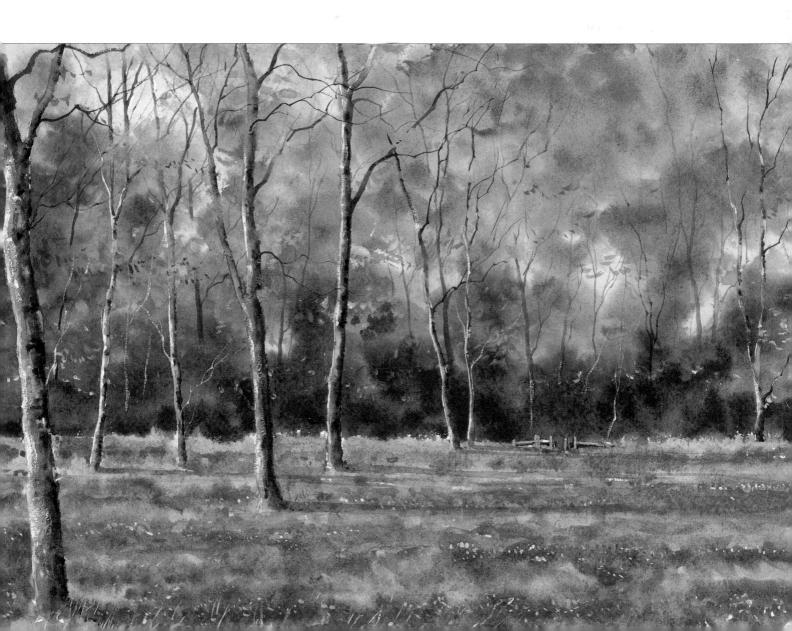

Introduction

The fact that you have picked up this book and started reading this page indicates that the types of paintings you are interested in are representative. You probably want them to look like a real place, perhaps to evoke a feeling of being there, or to remind you of a place that you enjoy, that makes you feel good. To this end a good knowledge of perspective, both linear and aerial, is a vital foundation.

To form an accurate representation of a place and to evoke a feeling of being there however, are not the same things. At first if your painting works on a purely representational level, this in itself can be quite satisfying, and as you practise techniques, becoming more and more familiar with the medium and how it behaves, your accuracy improves.

You may (as I have) hear the comment, 'Isn't it realistic, it's like a photograph'. Whilst this is usually meant as a compliment, as an artist you should want to achieve more, aspiring to capture the atmosphere, mood, and that vital impression of depth and distance that makes the viewer feel involved in the scene, almost as though they could walk into it.

I found that when I took up landscape painting, it gave me a whole new interest in the countryside. I enjoy walking a lot more and am constantly on the lookout for fresh inspiration and new subjects. I notice with satisfaction the same growing enthusiasm in my students, arriving at class enthusing about the sky they have just seen on their journey, analysing colours in a dry stone wall or a tree trunk, where once they saw just brown or grey.

Certainly watercolour landscape painting can be a source of great pleasure, especially as we all enjoy success and the compliments of our peers; conversely we can soon become frustrated and disillusioned if it is just not happening. With the examples, illustrations and instructions in this book, I hope I can provide sufficient tips and techniques to encourage you to achieve the results to which you aspire.

Miller's Dale, Derbyshire

406 x 305mm (16 x 12in)

A limited palette of just four colours has been used here to create a harmonious effect, giving the scene a feeling of calm. I used phthalo blue, lemon yellow, aureolin and burnt sienna. I do not use phthalo blue very often as it is a very strong dye that can overpower a painting, but it does make good blue/green shades with just water added and rich dark greens when mixed with burnt sienna. I added touches of white gouache with lemon yellow in places to create a light on top of the dark. Note how a feeling of distance has been created by rendering the furthest hill with the same thin blue wash as the sky.

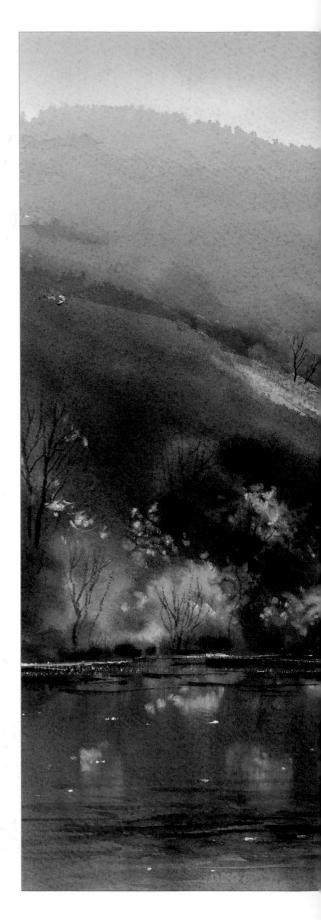

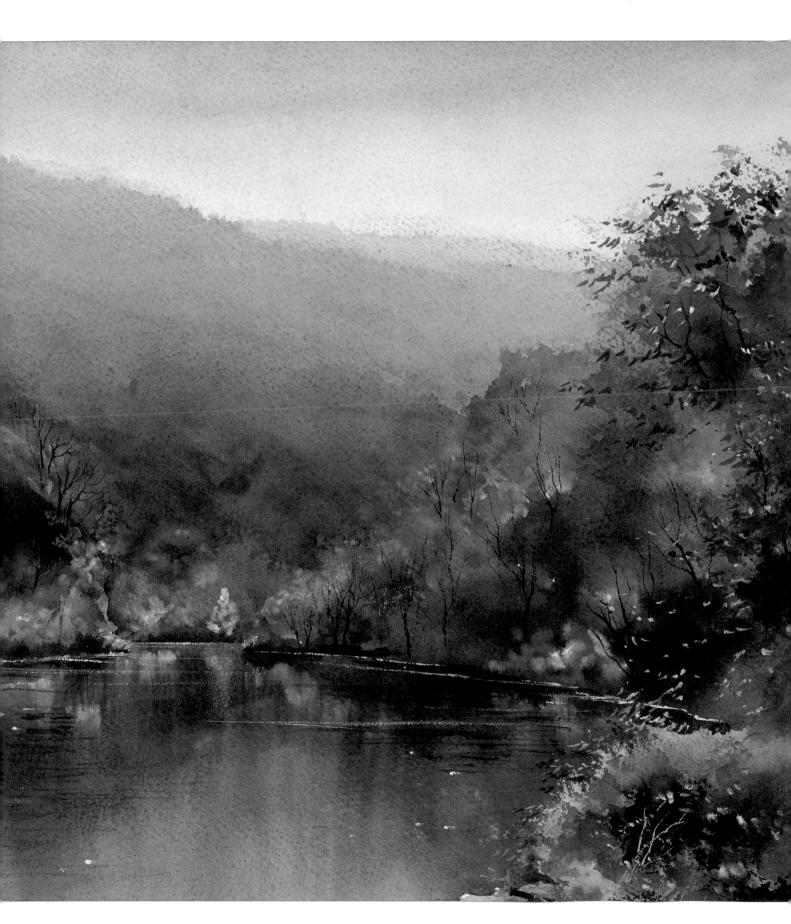

Materials

When you visit your local art shop for the first time, you are overwhelmed by the enormous variety of materials available to the watercolourist. There are papers by different manufacturers in blocks, pads and loose sheets, in four or five different sizes, three different textures and numerous different thicknesses. Paints come in several brands, in pans or tubes, large or small, in pre-selected sets or loose. The range of colours is enormous: nine or ten different blues, seven or eight different yellows and reds. Brushes seem to vary greatly in size, shape and particularly price, and while this bewildering array of products gives you plenty of choice, it's no wonder that beginners often start by buying products that they later wish they hadn't.

With this in mind I want to look briefly at the materials I recommend, and I have listed these in order of importance, in terms of how they ease the process and improve the result.

PAPER

I believe paper has the biggest effect on the finished result. Choosing the correct paper can make certain effects much easier to achieve. There are basically three surfaces, HP (hot pressed), Not (sometimes referred to as cold pressed) and Rough. To simplify this, think of them as smooth, medium and rough.

My personal preference is for Rough paper as you will see throughout this book, but a medium (Not) surface usually has enough texture to work with. I would not, however, recommend HP (smooth) paper for landscape painting as you don't have the benefit of the 'tooth', making certain dry brush effects almost impossible.

Students often ask me, 'What is the difference between a rag or cotton and a pulp-based paper?' To which my answer is, 'The price!' However, if you can afford to pay extra, it really does pay dividends. Ragbased paper is much tougher and more resilient; it is a joy to use. Look for good brands and don't buy anything lighter than 300gsm (140lb). Even at this weight I always prefer to stretch the paper so that it doesn't cockle and distort when it gets wet. This involves immersing it in water for about a minute before laying it flat on the painting board, where you leave it for another couple of minutes, during which time it expands. It should then be pulled flat and secured to the board by gummed tape, or stapled. This ensures that when it contracts as it dries, it pulls taut, creating a beautifully flat surface, crying out to be painted on.

Various different papers in blocks and loose sheets. I recommend Rough or Not surfaces for watercolour landscape painting.

PAINTS

There are basically two types of watercolour paint: artist quality and student quality. I have noticed in recent years that student quality paints have improved, but if you can afford the difference in cost it is worth investing in artist quality. The colours are generally brighter and richer, as they have a greater ratio of pigment to gum and so they go further, making student quality to some extent a false economy. I always prefer tubes to pans as they are in a semi-liquid state, making it much easier and quicker to mix plenty of washes for each stage of the painting. You will also find it much easier to vary the intensity of the colours with tubes. I squeeze the colours straight into the palette, where I have the following selection:

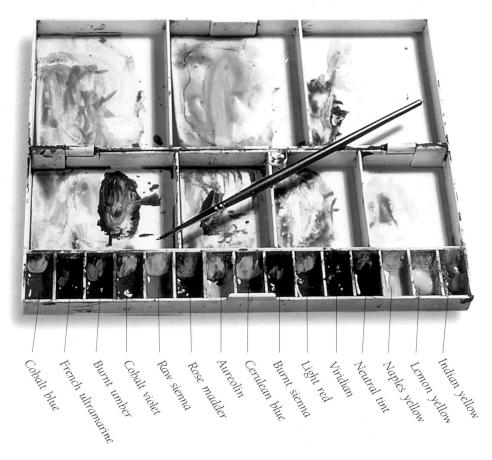

I do use other colours from time to time, but this is my basic palette. I sometimes add tiny touches of white gouache. At the end of a painting session I place a piece of wet kitchen towel over the fresh paints and close the palette to keep them moist. If you spend money on tube paints and allow them to dry out you might as well use pans.

I use a plastic folding palette with fifteen small wells into which I squeeze fresh tube colour. The order of the colours does not have a definite purpose but has evolved over time and I have become accustomed to it. The palette has a further seven deep wells in which to mix the colours, thus keeping mixed and fresh colour separate. The fact that the palette folds is essential, as at the end of a painting session I place a piece of damp kitchen towel over the wells and close it to keep the paint moist.

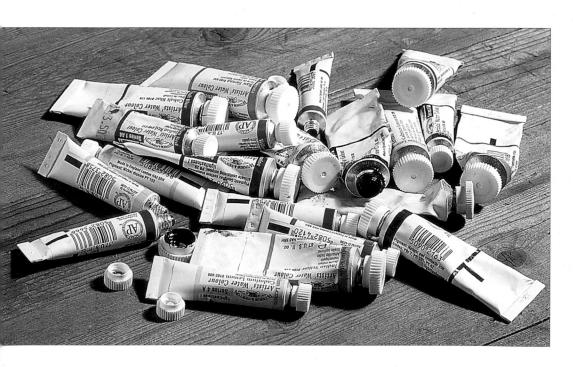

Tube paints. I prefer these to pans as the paint is semiliquid, which makes mixing washes quicker and easier. I use touches of white gouache to create certain effects, but this should never be put in your palette, or it will make the watercolours chalky.

BRUSHES

This is an area where I believe you can save money. I do all my paintings with synthetic brushes, apart from the extra large filbert I use for the skies, which is a squirrel and synthetic mix. My basic brush collection is as follows:

Round: numbers 4, 8, 10, 12 and 16 Flat: 1cm (½in) and 2.5cm (1in)

I also use a no. 2 liner writer or rigger. Check that this is very fine, as sizes vary according to brand. Ensure that all the brushes you buy have good, fine points, and when the point of a brush wears out, buy a new one, saving your old brushes for mixing, scumbling and various dry brush techniques.

Above: round and flat brushes. Whatever their size, round

brushes should have a good point.

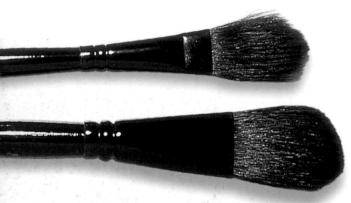

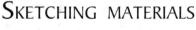

For sketching I use a spiral bound A4 cartridge pad, a 2B 0.9mm mechanical pencil and a putty eraser. I also find a 6B or 8B graphite stick or a large, flat, carpenter's style soft pencil very useful. Both of these are ideal for filling in large areas of tone.

Water soluble pencils are fascinating to work with, and are especially good for creating quick tonal value sketches (see page 13).

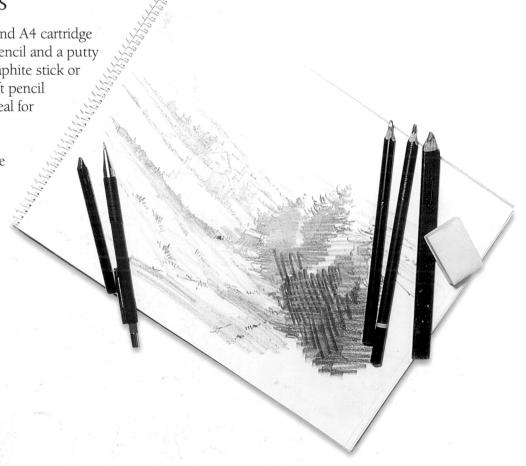

Other Materials

I have a variety of painting boards, mostly made of 13mm (½in) plywood. I also have a few made of MDF, which also makes good painting boards but is quite heavy and not ideal for carrying a long way. Hardboard or 6mm (¼in) plywood are not suitable as they are too thin and can bow if you stretch paper on them.

I use a collapsible water pot as it takes up less space, a bottle of masking fluid, which I find essential and an old brush to apply it. I have an old large brush that lost its point long ago, for cleaning the palette (don't use good brushes for this purpose as it blunts them), and a natural sponge for applying water to the paper.

Masking tape comes in handy if you want to mask a long, flat expanse, for instance a straight horizon on a coastal scene, and I use 5cm (2in) wide gummed tape or a staple gun for stretching paper.

A craft knife blade is useful for certain scratching and scraping effects (see step 17 on page 58). A lightweight aluminium ruler helps with verticals such as boat masts and telegraph poles. A hair dryer can be used for drying washes if you are in a hurry, but I generally prefer to let them dry naturally, as the colours continue

to mix and merge on the paper all through the drying process.

For painting outdoors you can avoid carrying a cumbersome painting board by buying paper in blocks, where the sheets are held in position with glue round all four sides. This makes it partly resistant to cockling, although in my opinion there is no substitute for stretched paper.

A painting board, metal ruler, gummed tape, masking tape, collapsible water pot, hair dryer, kitchen towel for lifting out paint, staple gun, pliers for — removing dried-on lids from paint tubes, a craft knife and blade, old brushes for cleaning palettes and applying masking fluid, a sponge and masking fluid.

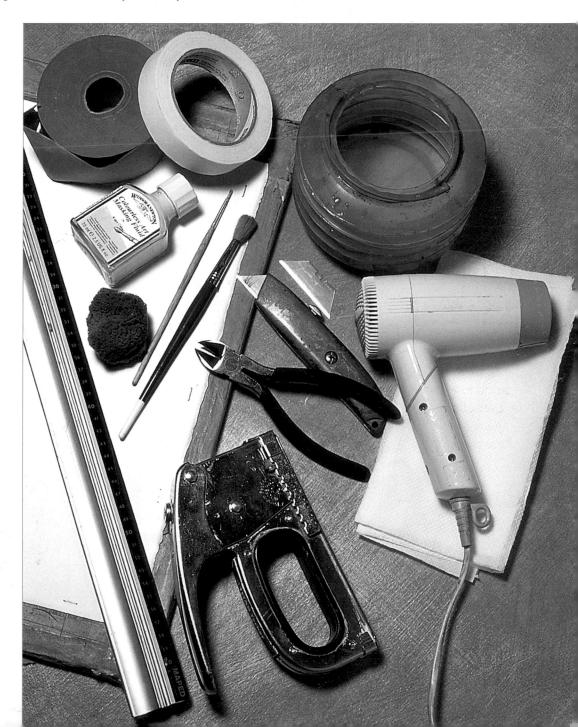

Drawing and sketching

To make a success of landscape painting, a knowledge of basic drawing skills is invaluable, as this is the underlying foundation of a satisfying and convincing picture. To make accurate drawings requires a rudimentary grasp of perspective and composition (covered in the next chapter), but to raise your drawings from simply accurate to lively and atmospheric depictions of what you see, you need to develop your powers of observation.

I often find people coming to my painting classes who say they can't draw when actually they are not looking thoroughly enough. Try comparing the height to width ratios of objects in the scene so the shapes look realistic. Look carefully at shapes and sizes; for instance, how many times does the length of a building or a tree go into the total width of the scene? These basics can be indicated with a few lines to make sure that the drawing is correct before continuing.

This is an ability most people can learn, but it takes a bit of application and practice. As you gain in confidence, the act of drawing becomes really enjoyable and no amount of time spent drawing and sketching is ever wasted as it hones your skills and sharpens your powers of observation.

Drawing and sketching is an excellent way to gather material from which to construct paintings. A full sketch book is a mine of information, which with accompanying photographs can provide the artist with subjects for hours of studio painting.

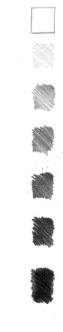

Explore the full range of tones from your pencil.

TIP

Don't spend too long on each sketch; limit yourself to fifteen to thirty minutes.

These are tonal value sketches, drawn quickly with ordinary graphite pencils. I use a 2B mechanical pencil and a 6B graphite stick which is excellent for filling in large areas of tone. The fact that the pencils are soft means that you can explore a full range of tones from a very pale grey to a rich black, (see the pencil swatches at top right). Don't forget to leave some white paper to contrast with the dark areas.

This long format sketch of Plockton, again, is all about tonal values. This time I have used a water soluble (dark wash) graphite pencil which is very good for laying in areas of tone quickly. These pencils are excellent for experimenting with; I scribble some graphite onto the corner of the page and pick this up with a wet brush. As with watercolour, the more water you add the paler the tone. In the final stage of the drawing you can tighten it up by working into it with both water soluble and ordinary pencil.

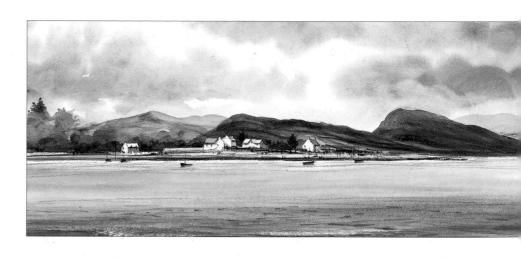

A couple of hours at a boatyard or jetty producing quick sketches of boats will really pay off if you come to do a painting of a coastal scene. At first painting a scene that contains a lot of boats is not easy, but as you practise, you gradually gain an understanding of their shape and structure. Beached boats make more interesting subjects because of the variety of angles and the fact that more detail is visible. See the painting on pages 62–3.

This is a half-hour watercolour sketch on tinted paper, containing sufficient information to work it up into a larger work later. I used white gouache on the walls of the farmhouse, which really makes it sing. Quick watercolour sketches, while untidy in places, can have a spontaneity often more difficult to capture in a more considered work.

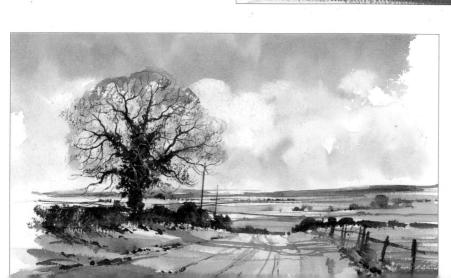

This very quick watercolour sketch is a monochrome, using just burnt umber. Having no other colours really makes you think in terms of tonal values; if your sketch is to have any impact, you have to explore the full range of tones available from almost neat paint to clear water. Choose dark colours such as Paynes gray, sepia and neutral tint for monochromes.

Using colour

Here is a selection of colour mixes taken from my basic palette, coupled with some suggestions of how you might use them. You will find it easier if you mix them in the order they are shown, but it is not just about the colours used; the density of a colour should vary enormously depending on where and how you intend to use it. Don't be afraid to mix the dark colours nice and strong, without adding too much water.

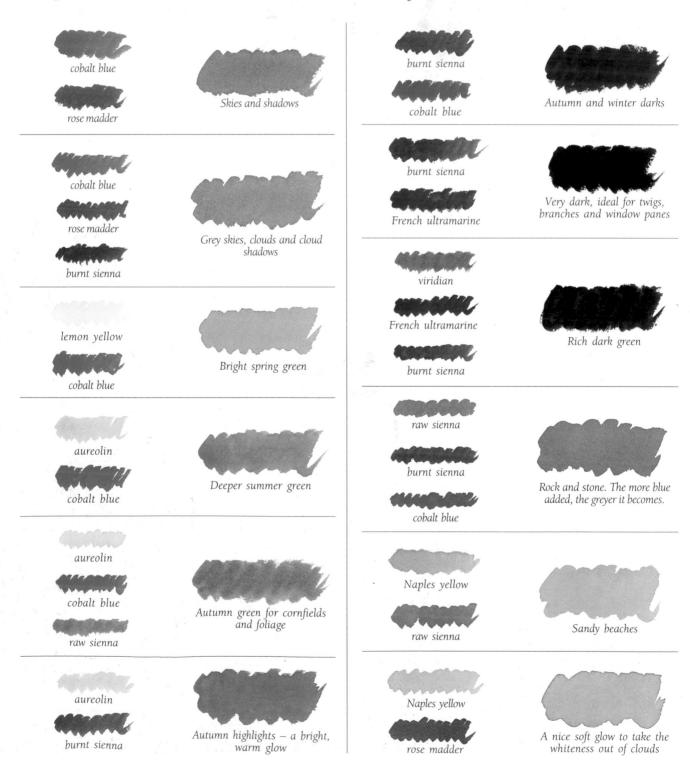

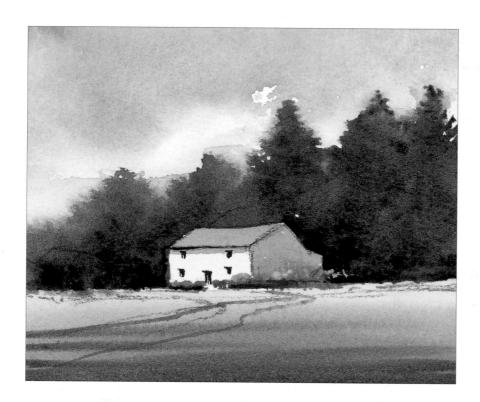

This small colour sketch shows how the three green mixtures can be used to create a feeling of light and distance. Immediately in front of the cottage the pasture has been put in with the bright spring green, followed by the deeper green, then right across the foreground is a sweep of the rich dark green. This then sandwiches the bright strip between the dark foreground and the dark fir trees behind the cottage, helping with tonal contrast as well as perspective.

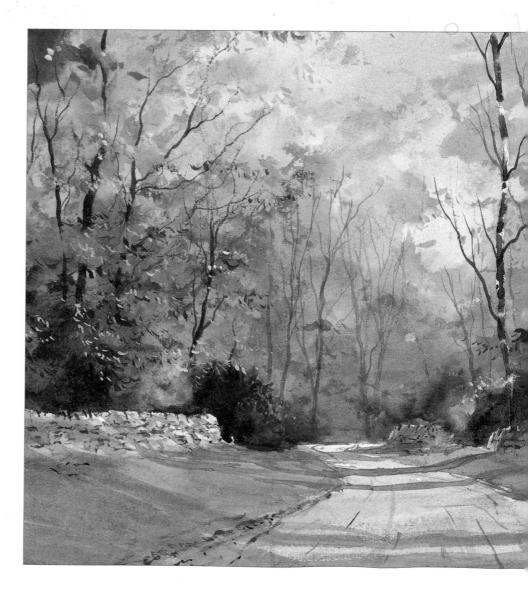

Here I have used the range of autumn colours shown opposite. The burnt sienna mixed with aureolin creates an authentic warm glow, but don't forget that in autumn there is still some green around. Note how the rich, dark greens are carefully placed to provide maximum contrast with the light on the left-hand wall and the top of the right-hand wall.

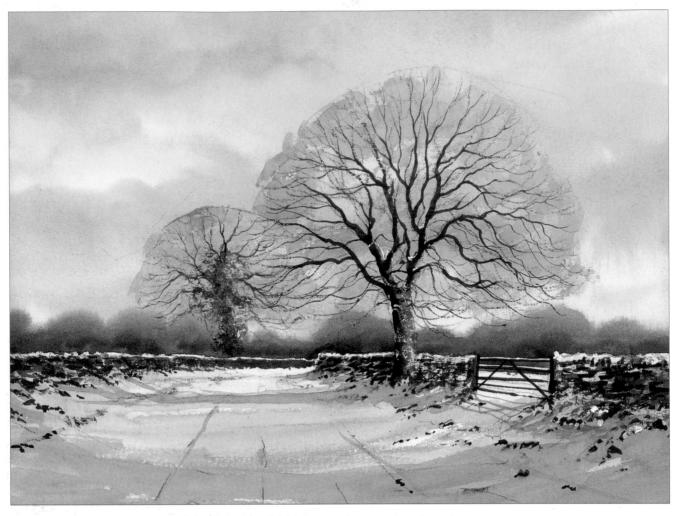

This snow scene makes good use of the medium and dark browns shown in the colour chart on page 14. Be careful when mixing the very dark colour that you allow the warmth from the burnt sienna to show through, or it can look too grey and lifeless. Note how the more distant tree has been rendered with a paler, slightly greyer colour to push it back into the middle distance, and the distant woodland is represented by an even paler, greyer mix. In this way, colours are used to create aerial perspective.

This coastal scene uses the sand colour shown on page 14. Starting with Naples yellow in the distance, I have then introduced Naples yellow and raw sienna, finally creating a shadow across the foreground with a wash of burnt sienna darkened with cobalt blue.

Notice how the far away strip of land is painted with the same cool grey used in the sky to push it right back into the distance.

In this stone cottage I have used raw sienna and also burnt sienna with the addition of a touch of cobalt blue for a slightly darker colour to suggest the stonework detail. It is important not to overdo the detail in a painting like this.

Notice how a thin glaze of cobalt blue and rose madder, matching the sky, is used to create a shadow on the front of the building, giving it a three-dimensional look.

Linear perspective

To construct an authentic looking landscape, you need a rudimentary knowledge of linear perspective. This can seem very complicated and technical, so it is my intention to focus only on the basic elements and how to apply them to solve some of the problems you may come across. Once the penny drops, it all falls into place and you don't forget it.

Linear perspective works by making objects look further away because they appear smaller. In the example shown in Figure 1 we have a straight-on view of a house on a flat, level plane. To draw this requires no knowledge of perspective, but it is not very interesting; observe in this example all the parallel lines shown with dotted lines. Now look at Figure 2. This shows the same house with the same parallel lines viewed obliquely. Immediately this image becomes more interesting – so what has changed? All the parallel lines now go away from the viewer, leading us into the picture and converging on a point called the vanishing point. This causes all the vertical lines to diminish as the eye follows them into the scene.

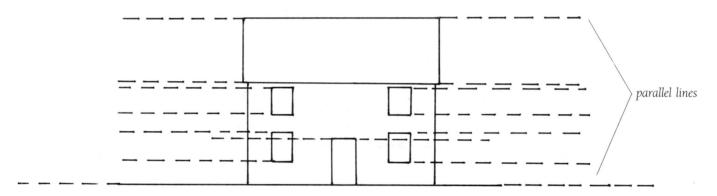

Figure 1

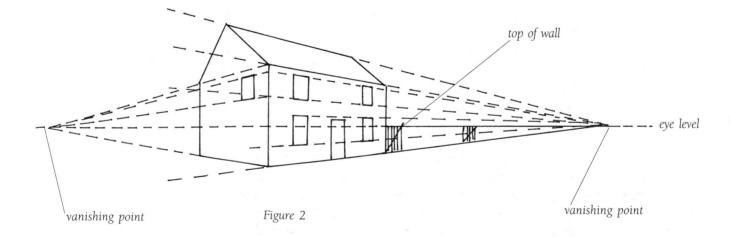

A simplified example of this effect is shown using some telegraph poles on a roadside in Figure 3.

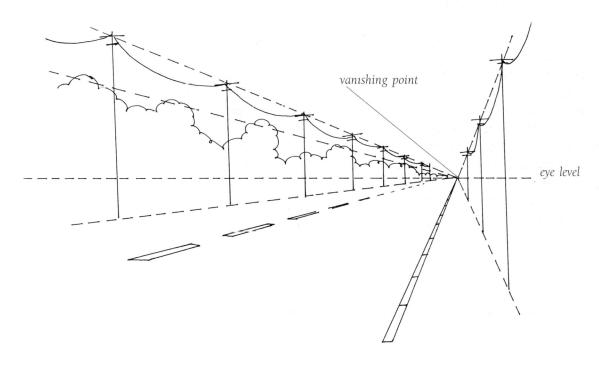

Figure 3

Notice how, when you take all the parallel lines to the vanishing point, you can plot your verticals to create the diminishing effect. Even the row of bushes indicated on the left roughly follows a line to the vanishing point.

The vanishing point is always on the horizon or eye level. If you are looking out to sea, the horizon is where the sea meets the sky so it is very easy to see. Most of the time, however, it is obscured by hills, trees, buildings etc., so you need to ask yourself, 'Where is the horizon/eye level?' To find this, you need to be aware that all parallel lines below the eye level slope up to it and all those above the eye level slope down to it. Note in Figure 2 how the roof top, guttering, upstairs windows and top of the downstairs windows slope down. The base of the building and bottom of the downstairs windows slope up, so your eye level is somewhere in the downstairs window area, which when you think about your height in relation to a house, makes sense.

If you are working outdoors, hold up a ruler or pencil at arm's length between you and the scene, following the parallel lines that slope up and down. The point at which they converge is the vanishing point. Now form an imaginary level line that goes horizontally straight through this point from one side of the paper to the other, as shown in Figure 2. This is the horizon/eye level. You can then indicate this lightly on the paper. Alternatively, look for one of the parallel lines that neither slopes up or down but runs horizontally across the paper with sloping lines above and below; this will be on your eye level, (see the top of the wall in figure 2).

If you are working from a photograph, establishing the vanishing point and eye level is easier. Place a ruler along the parallel lines and draw them in lightly (see figure 4). You can easily see where they converge. Then rule a horizontal line through to establish the eye level.

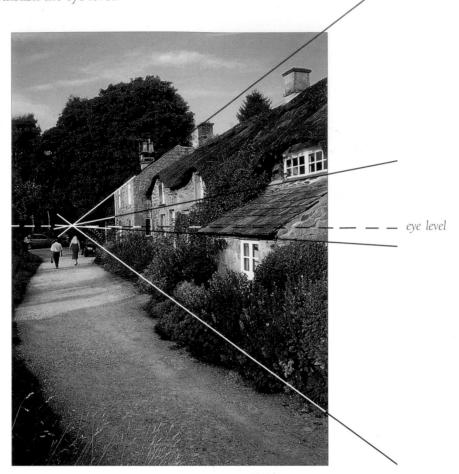

Figure 4
Note that in this example the eye level is above the heads of the people walking. This is because I stood on a wall to take the photograph, making my eye level higher than theirs.

If you look at the side of the building shown on the left of Figure 2 (page 18), you will see a second set of parallel lines leading to a second vanishing point. This is because, in life, this wall is at right angles to the front wall, not parallel to it. Though these lines have a different vanishing point, they have the same eye level: this is called two point perspective. Remember you can have numerous vanishing points depending on the complexity of the scene, but you can have only one eye level.

It is worth considering briefly how to place the point of the gable (Figure 5 point C) as this often baffles the aspiring artist. There is a relatively simple formula to achieve this, explained in this example.

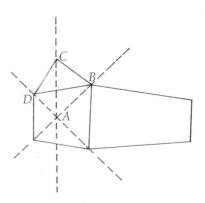

Figure 5
To position the end gable, take the basic rectangle that makes up the side of the building. Put a fine pencil line through each corner, crossing in the centre at point A. Draw a vertical through point A. Gauge the slope of the roof (you can do this by eye) and draw it from point B up to meet the vertical line, at point C. Draw a line from C to the far, top corner of the rectangle, D.

Don't be caught out when you view a scene on an incline; the level parallel lines are exactly the same except for the fact that the road itself, which in effect is the bottom of the buildings and walls, is not a parallel line – see Figure 6.

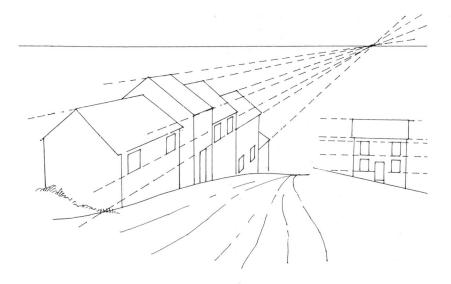

Figure 6
In this example we see a row of buildings on an incline.
Note where the eye level is: up in the sky! This is because, although all the parallel lines that make up the shapes of the buildings remain the same, your viewpoint has changed. You are uphill from the scene, so your eye level is above it.

It is often the case that you find a scene that appeals to you, but it does not contain a natural perspective that will give you the opportunity to create a feeling of

distance. An example of this is the simple sketch in Figure 7. This represents a popular location on a canal, where there are two boathouses on opposite banks; they are roughly the same distance from the viewer. As an artist we do not have to accept it as it is.

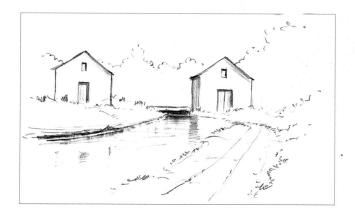

Figure 7

Now look at Figure 8. I have taken the right-hand boathouse and enlarged it, creating perspective and bringing it nearer the viewer. This immediately improves

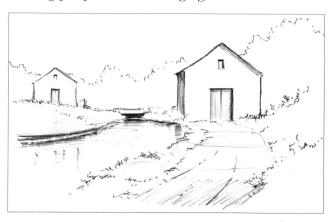

Figure 8

the composition as the positioning of the two buildings means that they now complement each other, rather than competing for the viewer's attention. It doesn't matter that it's not as accurate; your objective should always be to create the best interpretation.

Aerial perspective

Having considered how to use linear perspective to create a feeling of distance, we can now look at how to reinforce these principles by means of aerial perspective. Put simply, aerial perspective creates a feeling of distance by observing the effect the atmosphere has on the landscape, making the distance mistier, greyer and altogether less distinct than the foreground. This is a progressive effect i.e. the further away, the paler and less clear the scene becomes.

Nature, however, does not always make this easy for us. On a clear, bright morning without a cloud in the sky, the distant colours can be almost as vivid and sharp as the foreground. If we want a painting with such a feeling of depth and distance that the viewer almost feels they could walk into it, we need to interpret what is in front of us rather than just copy it exactly as it appears. After all we could produce an accurate record with a camera.

We can create aerial perspective by applying the following:

- Cool colours (blues and greys) recede, warm colours (reds, browns and yellows) come forward. Look at the two squares of colour on the right. They are the same size on a flat piece of paper, but somehow the red one has more impact and looks nearer to you.
- Lighter tones look further away than darker ones. Look at the example shown below
- When we view a scene, we can make out more detail in the foreground, but this detail gets progressively less as we travel into the picture. This seems like stating the obvious, but often what we know to be a fact, we don't think of applying to our paintings.

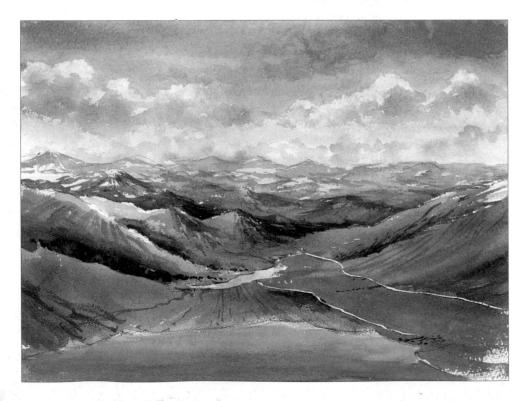

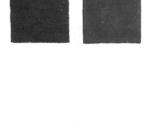

This range of mountains was based on a photograph taken from an aeroplane window. You can see such a long way that it is perfect for illustrating aerial perspective. Look at the most distant hills: these are merely suggested with a pale blue wash using the same colour as the sky. Warmer colours and stronger tones are very gradually introduced as we come further forwards in the painting.

Consider the two paintings below. There's no doubt that the one on the left looks like what it is supposed to be; green hills and pastures with a crisscrossing of dry stone walls and trees under a blue sky.

Now look at the painting on the right: the same scene, but what a difference when we apply some methods to create aerial perspective. First of all note how the sky is darker in tone at the top and lighter towards the skyline. Despite the fact that the distant hills on the photo were green, I've painted them in a pale bluegrey, the furthest hill indicated with the palest wash. A bit of light and atmosphere has been injected into the scene with the bright area in the centre, the tones gradually getting stronger and colours getting darker towards the foreground. Note how the distant trees are painted in softer, mistier shapes, becoming more clearly defined nearer the foreground. To emphasise this effect a hint of brown (a warmer colour) has been added to the nearer trees. Finally a few touches of detail: grasses, foliage etc., have been added to the foreground – remember that the nearer you are to something, the more detail you see.

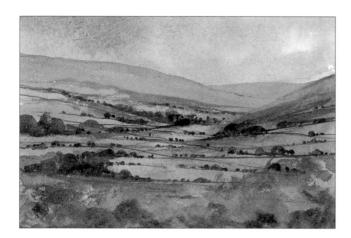

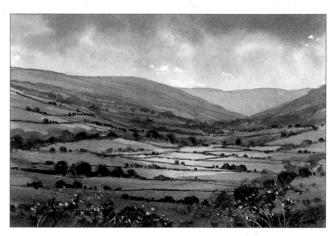

Now look at the painting below. Think about this simple scene and consider how both linear and aerial perspective has been used to create a feeling of depth and distance.

In this simple scene, linear perspective has been used to take the lane right into the distance. All the lines created by the tops of the hedges, the bottoms of the hedges and edges of the track converge on the eye level in the distance.

Also the trees gradually become smaller, less detailed and cooler in colour as they recede into the scene, thus employing aerial perspective as well.

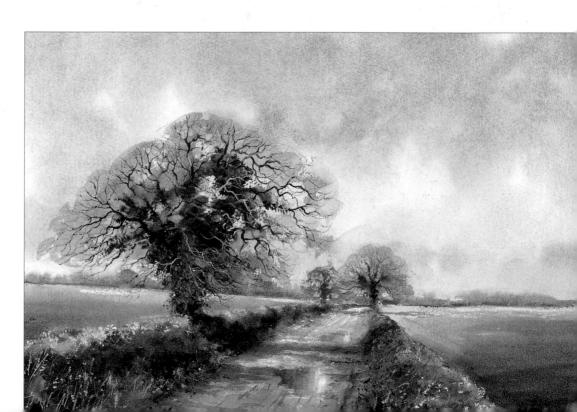

Skies

I believe that in most landscape paintings, whatever the medium, the sky is the most important element, as it sets the whole mood and atmosphere for the scene. Get the sky wrong and it is difficult to make a success of the painting; paint a good sky, however, and you are on your way, enthusiastic and motivated by the promising start.

The key to painting successful skies is preparation. This means taking the time to think about what you want the finished sky to look like, deciding which colours you intend to use and mixing all the initial washes before you put brush to paper.

When you are ready to commence, try and limit the time you spend painting the sky to thirty to forty seconds for each stage. I have seen more skies ruined by overworking than any other fault. Remember also that the glow in a watercolour depends on the light penetrating the transparent washes and reflecting off the paper, and the more you keep swirling the paint around, the greyer and more dense it becomes.

Here are seven different sky painting methods that are well worth trying. Paint them quite small at first, maybe filling a large sheet with numerous postcard size examples until you become more confident.

A WET IN WET SKY WITH THREE WASHES

Wet the paper over the whole sky area with a 2.5cm (1in) flat brush, and mix three washes: Naples yellow with burnt sienna, cobalt blue with cobalt violet, then the same again with burnt sienna added. I painted this sky with a large filbert wash brush.

2 Paint Naples yellow and burnt sienna across the lower part of the sky, then the cobalt blue and cobalt violet across the top, followed by the third mixture across the very top and a few dashes across the middle to represent hazy cloud shadow. Try to paint rapidly and then leave it alone.

3 The finished sky. When dry this will look quite different to when it was wet, the colours should have gently fused into one another, going slightly paler and creating a soft diffused look.

The soft, diffused shapes create a gentle effect and the slightly milky colour is ideal for portraying winter afternoon light. Don't judge your work while it is still wet —walk away from it and you'll be pleasantly surprised by the magic that takes place on the paper in your absence.

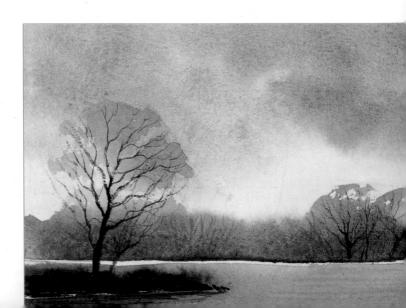

DABBING OUT CLOUDS

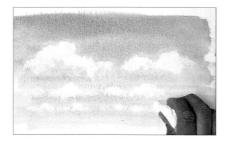

I Mix two washes: cerulean blue for a cool colour near the horizon and cobalt blue with cobalt violet for a warmer blue at the top. Wet the paper with a flat brush, then using the same flat brush apply the washes with smooth horizontal strokes. Wetting the paper allows you more time before the washes dry. Dab out cloud shapes using a piece of kitchen towel. Scrunch up the kitchen towel to make smaller clouds lower down.

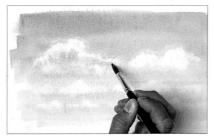

2 You can leave the clouds as they are, or add shadows. Wet each cloud individually with clean water and immediately drop in a grey created with cobalt violet and cerulean blue.

It is very important with this example to make each subsequent row of clouds smaller as it gets nearer to the horizon. This creates that all important feeling of distance and is what we mean by aerial perspective (pages 22–23).

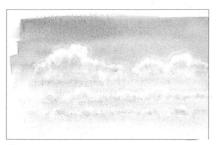

3 The finished sky.

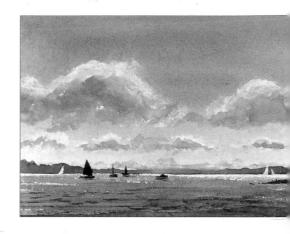

LIFTING STREAKS WITH A BRUSH

I Mix two washes: cobalt blue and French ultramarine and a thinner wash of cobalt blue. Wet the whole page with clean water. Apply the first wash at the top, bringing it two thirds of the way down the paper, using the flat brush. Then change to the second wash so that the sky is cooler towards the horizon. Wash and dry the brush immediately until it is just damp and use it to lift colour out.

2 Keep cleaning and drying the brush to keep it 'thirsty'. Twist and turn the brush across the paper to make cloudy streaks, sloping them slightly uphill. Allow to dry.

This sky method works well when depicting a large expanse of flat land under a bright summer sky. The window for lifting out the streaks of colour is very small so you need to be well prepared and work quickly. The twisting motion of the brush helps to make the streaks look like cirrus clouds; if you don't twist and turn it enough, they are much less convincing.

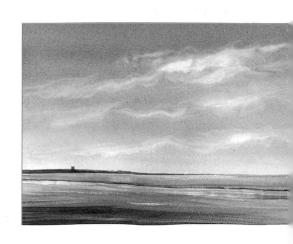

A sunset sky

1 Mix three washes: a thin wash of lemon yellow; raw sienna with light red to make orange and cobalt blue with rose madder to make purple. Wet the background with a flat wash brush and clean water. Then drop in the washes from the bottom upwards: lemon yellow, then the orange in the middle, then bluey purple at the top.

2 Working quickly so the background is still wet, drop in cloud shapes using a no. 16 round brush and a mix of cobalt blue, rose madder and light red. This mix should be slightly thicker than the previous washes so that it spreads slowly into them without creating unsightly cauliflowers. Make the clouds larger at the top and smaller nearer the horizon, again to help with that feeling of distance.

3 The effects of this wet in wet technique will carry on changing as the loose cloud shapes soften into the previous washes until the painting is dry.

With a sky like this one you can not make out much detail on the land as everything is reduced to silhouettes. These dark shapes can be made up of stronger versions of the colours used in the sky so the whole scene has harmony — the benefit of the limited palette.

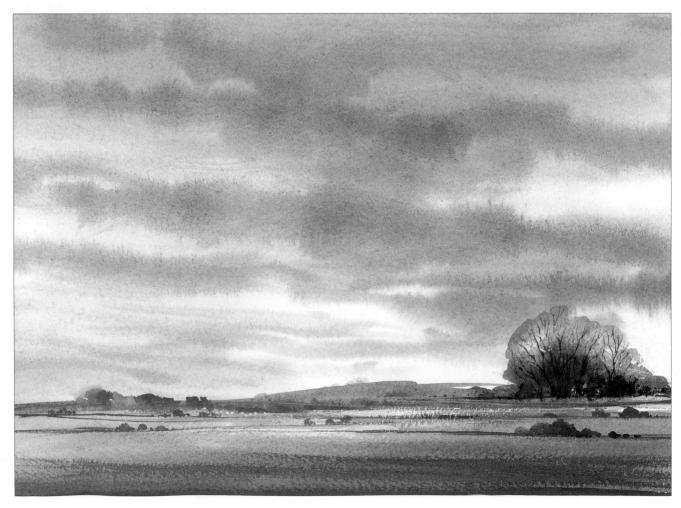

Four washes on a wet background

I First mix four thin washes: raw sienna, cobalt blue, neutral tint and sepia. Wet the paper with a sponge and with a filbert wash brush, apply a thin wash of raw sienna in the lower sky with the side of the brush. Clean the brush then wash on cobalt blue at the top, leaving some white paper. Add a wash of neutral tint at the top and bottom.

2 Paint on sepia at the top of the sky to darken it. Slope the board to allow the washes to spread into each other; do not work them with the brush for long as this will mix the raw sienna and cobalt blue, creating a grey-green. Do not judge the sky while it is wet, because it will lighten as it dries.

This combination of strong colours creates a dramatic effect, which can depict approaching bad weather and look very atmospheric. You have to be careful, however, to float the colours in and leave them to work their magic, as the more you swirl them about the more you are in danger of blotting out the light area in the centre, which you can use to great effect to illuminate the land.

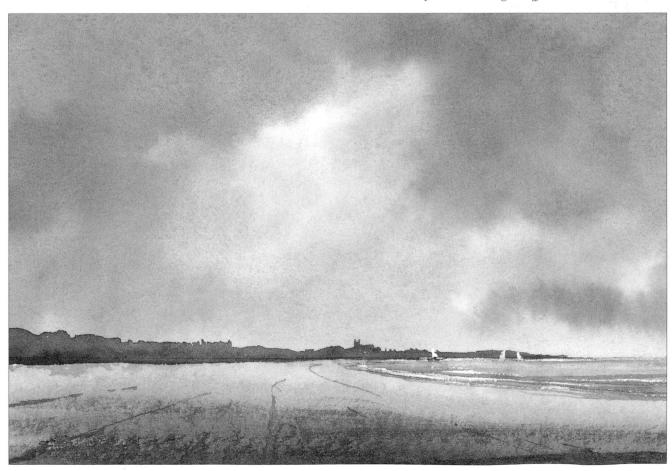

A GLAZED SKY THAT IS LIGHTER AT THE TOP

l Unlike the previous skies which are lighter at the horizon and darker towards the top, this one is reversed. Mix three separate glazes: cadmium red, cobalt blue and neutral tint. They should all be quite thin so that they will be transparent. Apply the first wash of cadmium red with a no. 16 brush from the horizon line, thinning it towards the top with water so that it fades out to white. Leave the painting to dry completely.

2 Repeat this procedure with the cobalt blue, again softening with water towards the top. Allow to dry completely.

3 Repeat once again with the final glaze of neutral tint.

4 The sky when completely dry.

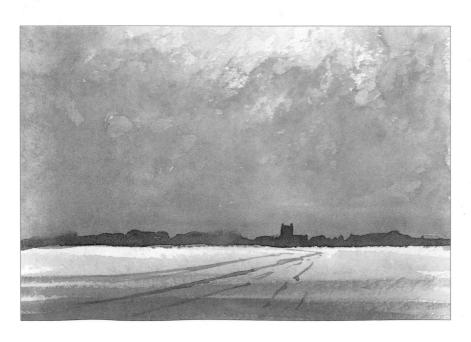

This type of sky is very useful for snow scenes or ploughed stubble fields where you can achieve a sharp contrast at the horizon with the dark of the sky against the brightly illuminated land.

SEPARATE GLAZES

Using a no. 16 round brush, wet the top right-hand side of the painting only. Wash in cobalt blue across the top of the whole painting and cerulean blue lower down. Soften with clear water to avoid any hard edges. Allow the painting to dry completely, so that later work will not disturb these washes.

2 Lay in grey cloud on the dry paper using a wash of neutral tint with just a touch of rose madder. Soften a few of the cloud edges with a damp, but not wet, clean brush. Don't soften all the cloud shapes as it is more interesting to have variation, with some hard and some soft edges. Leave this to dry.

3 Using the same mix of neutral tint and rose madder, add some dark cloud to the top left of the scene, again softening in places with a clean, damp brush.

As there are three glazes on this sky, it is important that each one is quite thin and transparent so that with each subsequent glaze you can glimpse the previous one underneath.

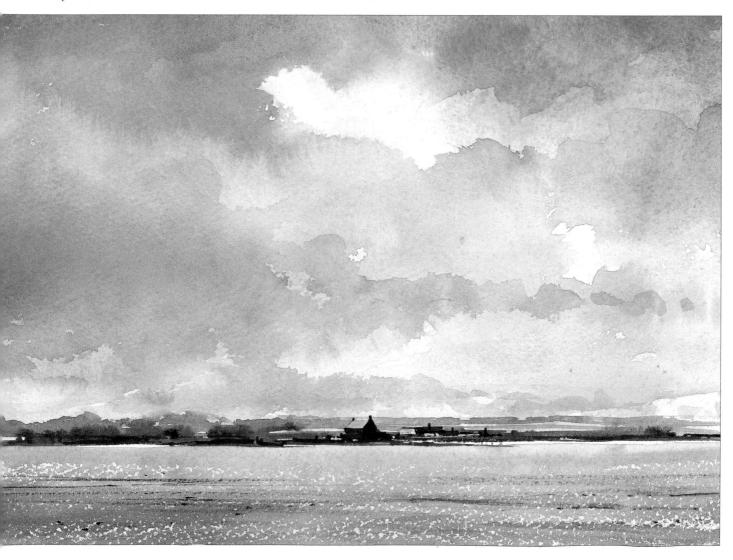

Holmfirth

During a hot summer's day walking in the hills above the attractive Yorkshire town of Holmfirth, I came across this scene and it struck me that the position of the track, fences and scattered buildings created a perfect perspective.

If you look at the photograph and sketch shown below, you can see how I have redirected some of the fences and altered the position of the telegraph poles to emphasise and lead the eye towards the distant hills. However, the basic ingredients were all there.

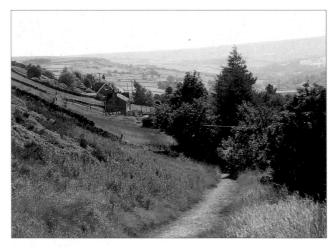

I felt that this scene had a natural perspective that led the viewer's eye down the path, along the line of trees and on to the small cluster of buildings in the middle distance.

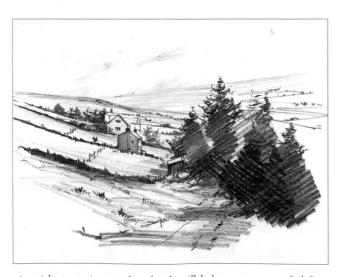

A quick, ten minute value sketch will help you to get a feel for the scene. Note how darkly I have rendered the fir trees on the left: this reminds me when doing the painting that there is a real counterchange of light against dark in this section.

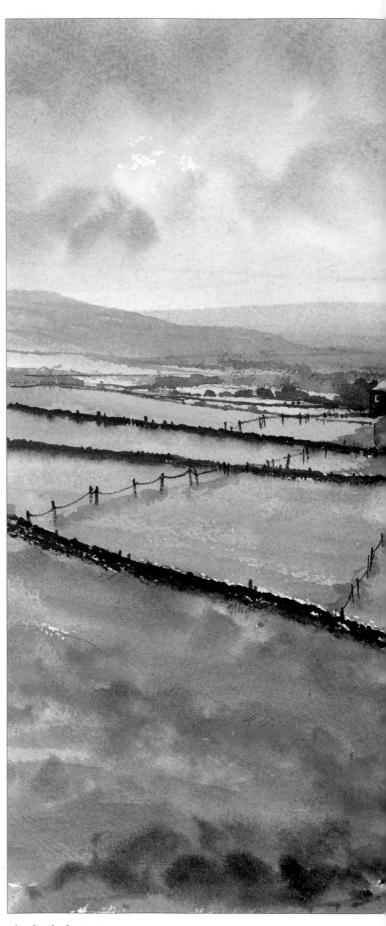

The finished painting

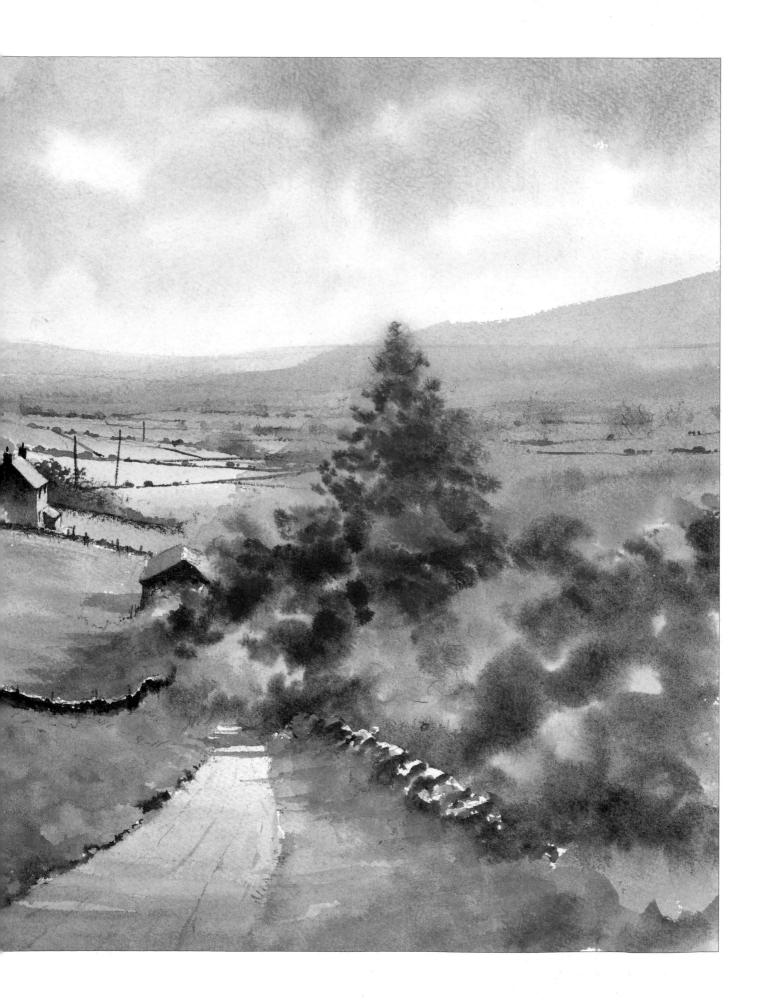

YOU WILL NEED

Rough paper, 510 x 360mm

(20 x 141/4in)

Masking fluid

Cobalt blue

Cobalt violet

Raw sienna

Burnt sienna

Lemon yellow

Aureolin

French ultramarine

Naples yellow

Viridian

Old paintbrush

Large filbert wash brush

Round brushes: no. 8, no. 4,

no. 12 and no. 16

Kitchen towel

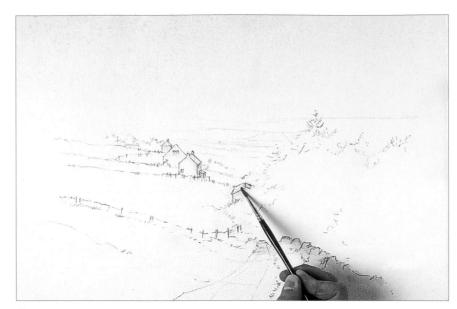

1 Draw the scene. Apply masking fluid to highlight areas on the buildings and the tops of the walls using an old paintbrush.

TIP

Do not leave masking fluid on a painting for more than a day or two; it can tear the paper when you remove it.

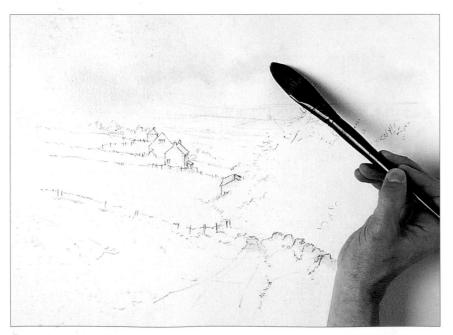

2 Mix all your sky colours before beginning to paint, as you will need to work quickly once the paper is wet. Mix cobalt blue with cobalt violet; raw sienna with a little burnt sienna; and cobalt blue with cobalt violet and burnt sienna. Wet the sky area with clear water using a large filbert wash brush. Paint the lower part of the sky first, washing the raw sienna/burnt sienna mix on to the wet paper.

TIP

Drop the sky wash below the top of the distant hills. If you stop where the hills meet the sky, you will get an unnatural line.

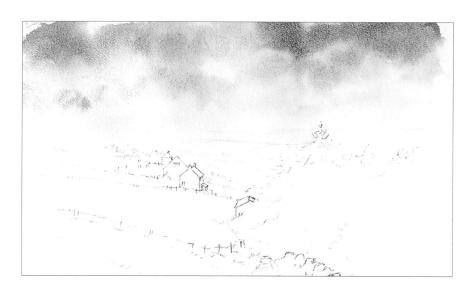

3 Next drop in the cobalt blue, cobalt violet mix above the first wash, working quickly while the paper is wet. Lastly wash on the cobalt blue, cobalt violet and burnt sienna mix at the top of the painting. The darkest wash always goes at the top, with the sky lightening towards the horizon to create perspective. Slope the board downwards just a few degrees for a moment to allow the washes to run into one another, then lay it flat and allow the painting to dry.

4 Mix all your colours for the next wet in wet section: cobalt blue and cobalt violet; the same colour with burnt sienna added; a thin wash of lemon yellow; green mixed from aureolin and cobalt blue and finally raw sienna, burnt sienna and cobalt violet. Using a no. 12 brush, paint stripes of colour to merge with one another. Begin with cobalt blue and cobalt violet, then below that the slightly greyer mix, then the warmer raw sienna, burnt sienna and cobalt violet; then lemon yellow for sunlit fields. Take a no. 8 brush and drop in a green/brown mixed from aureolin, French ultramarine and burnt sienna for distant trees.

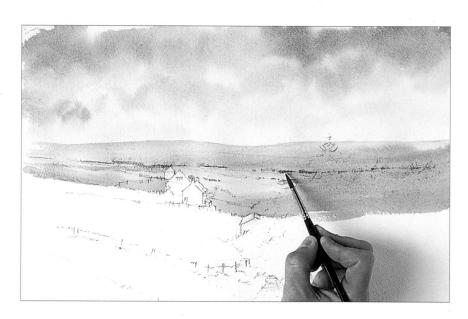

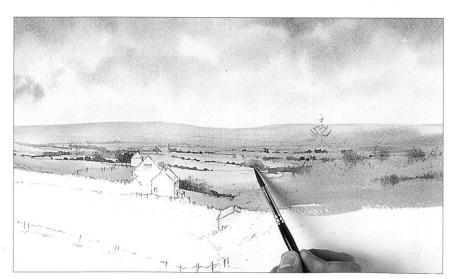

5 While the paint is damp, drop in a suggestion of walls, hedges and trees in the distance using cobalt blue, cobalt violet and burnt sienna for a warm grey. Allow the painting to dry.

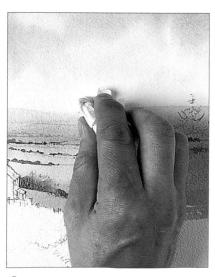

6 Soften the line where the distant hills meet the sky using a wet brush, and dab it with kitchen towel.

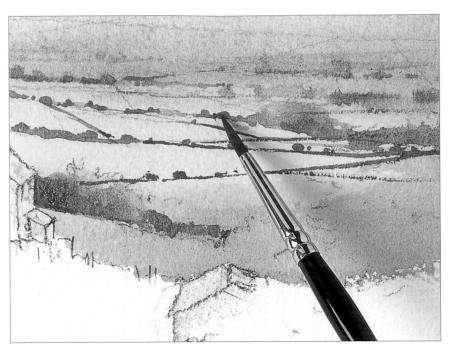

7 Use a no. 4 brush and a medium brown mixed from burnt sienna and cobalt blue for the dry stone walls in the middle distance. Add a darker brown of burnt sienna and French ultramarine nearer the foreground.

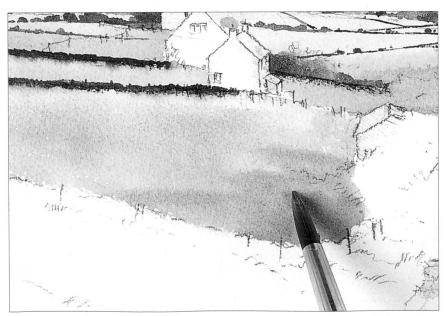

8 Remove the masking fluid from the left-hand wall. Paint the wall and fence posts with burnt sienna and French ultramarine. Paint the greens of the fields with a mix of aureolin and cobalt blue. Mix a straw colour from Naples yellow and cobalt violet and use this to soften the bottom of the wall. Add a hint of lemon yellow for the effect of sunlight in the field, and cobalt blue to darken the green. Allow the painting to dry.

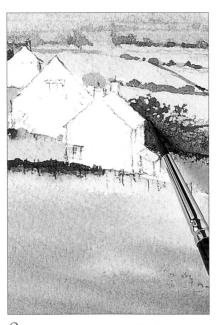

9 Remove the masking fluid from the buildings. You may need to tidy the edges using the background colours.

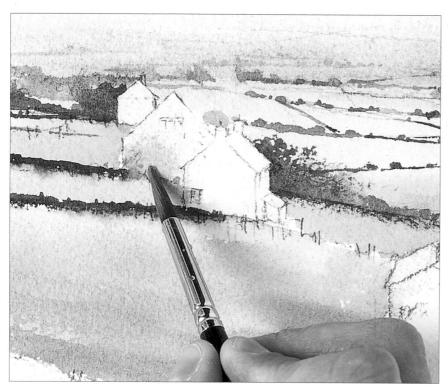

 10° Make a thin mix of cobalt violet and burnt sienna and wash a pink glow over the area of the buildings using a no. 8 round brush. While this is still wet, mix a green from aureolin and cobalt blue and paint in the bush in front of the buildings wet in wet to achieve a soft-edged shape.

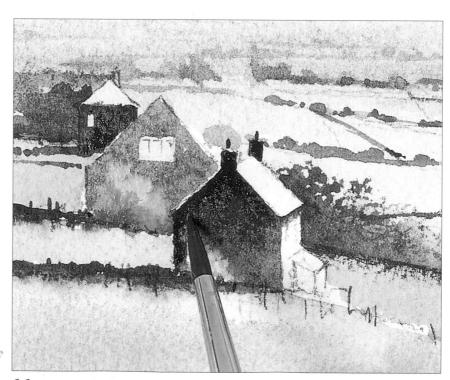

1 Drop in a mixture of burnt sienna, cobalt blue and cobalt violet for the shadowed part of the buildings. Immediately drop lemon yellow into the bush and allow it to spread upwards. Then, using a darker mixture of French ultramarine and burnt sienna, darken the left-hand and right-hand buildings, sandwiching the middle one between them. Leave a white ridge between the buildings to represent the slope of the roof.

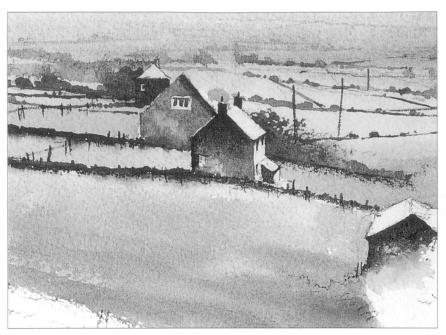

 $12\,$ Use the same brown and a no. 4 brush to draw in the finer details of fence posts, windows and telegraph poles. Paint the very dark wall of the building on the extreme right. Dampen the area of foliage in front of it and add lemon yellow to contrast with the dark wall. Take care to leave the roof of this building white paper for the time being.

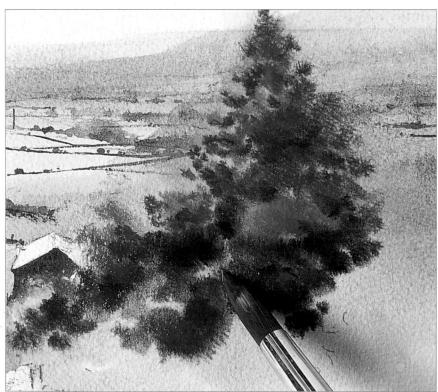

TIP
In the reference photograph the fir tree reaches exactly the same height as the distant hill, but this will look contrived in a painting, so vary it by making the fir tree taller.

At this point I decided that the hills on the right and left of the picture should be steeper, creating a deep valley typical of this part of the country. Mix large quantities of three colours for the middle to right-hand side of the painting: lemon yellow; aureolin with cobalt blue and viridian with French ultramarine and burnt sienna. Wet the area first and wait for the shine to go (this indicates that the paper is damp rather than wet through). Then drop in the darkest green first for the fir tree. If the paint spreads wildly, the area is still too wet, so wait a few seconds longer. Drop in lemon yellow with a no. 16 brush.

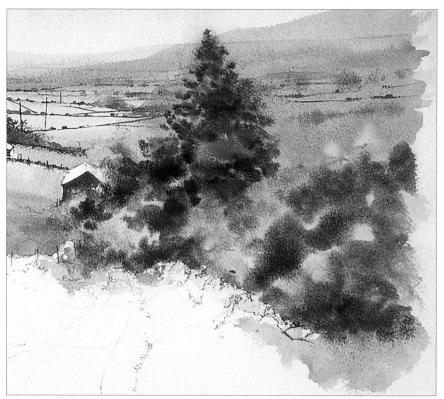

Add more of the lemon yellow and more mid green, painting wet in wet. Mix burnt sienna with Naples yellow and drop it in where the grasses soften into the green. Paint the right-hand side of the scene with a touch of lemon yellow, and add darker greens, as with the fir tree. Add a rich yellow mixed from Naples yellow, burnt sienna and lemon yellow at the bottom right and tip the board upwards to encourage the colour to spread upwards, indicating the tufts of grasses. Allow the painting to dry.

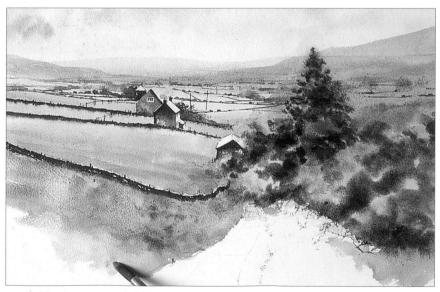

Mix more colours in preparation for painting rapidly wet in wet from the middle ground wall downwards. Rub off the masking fluid from the wall and paint it using French ultramarine and burnt sienna. Paint the darkest details such as fence posts using this same mix. With a no. 12 brush, soften the bottom edge of the wall using Naples yellow mixed with burnt sienna. Paint a little pink below this, mixed from Naples yellow and cobalt violet, to tie in with the sky, then continue downwards with a green mixed from aureolin and cobalt blue with a hint of raw sienna.

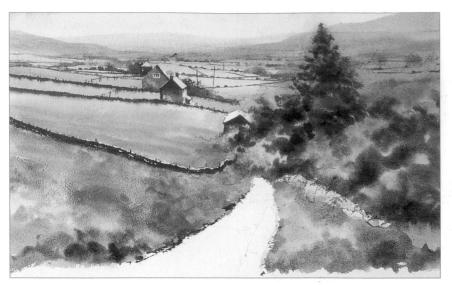

16 Work wet into wet on the foreground. Mix a green from aureolin and cobalt blue, add burnt sienna to brown it and drop it in to create grassy tufts. Add touches of pink. Use the dark green to paint rich darks in the foreground to give it a rough, textured feel, softening the edges. Paint the foreground area on the right-hand side of the path in the same way, using pink, green and dark green.

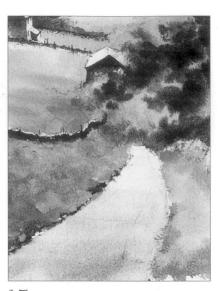

17 The path should look as though it is reflecting colours from the sky. Paint on watery mixes of Naples yellow and burnt sienna and cobalt blue and cobalt violet, allowing them to merge on the paper. Leave some areas white for intense brightness. Allow to dry.

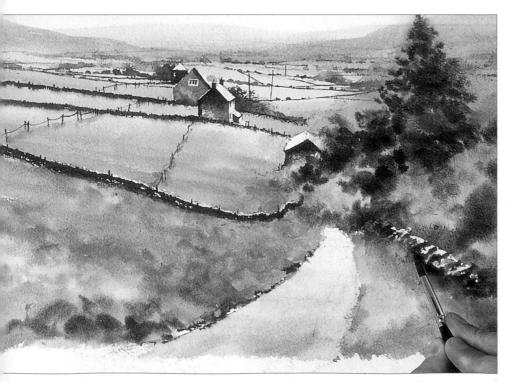

Add fence posts in the left-hand field using a no. 4 brush and burnt sienna mixed with French ultramarine. These will lead the eye into the painting and create linear perspective. Remove the masking fluid from the right-hand wall and paint it using the same dark brown, but leaving highlights of white paper.

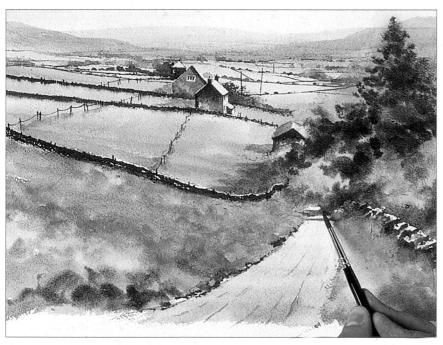

Use burnt sienna to suggest red bracken under the dry stone wall and on the right-hand side of the path. Mix cobalt blue and cobalt violet (sky colours) for shadows. The light is coming from the right in this scene, so shadow the left-hand side of the roof of the building on the far right. Indicate shadows cast to the left from the buildings and trees.

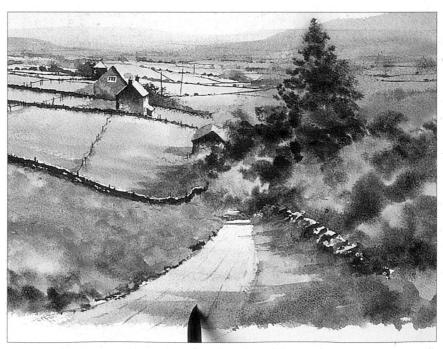

Paint broad strokes of shadow across the foreground to bring it forward, softening the top edge a little with a damp brush. Drop in burnt sienna to warm the shadow at the bottom, and paint perspective lines on the path.

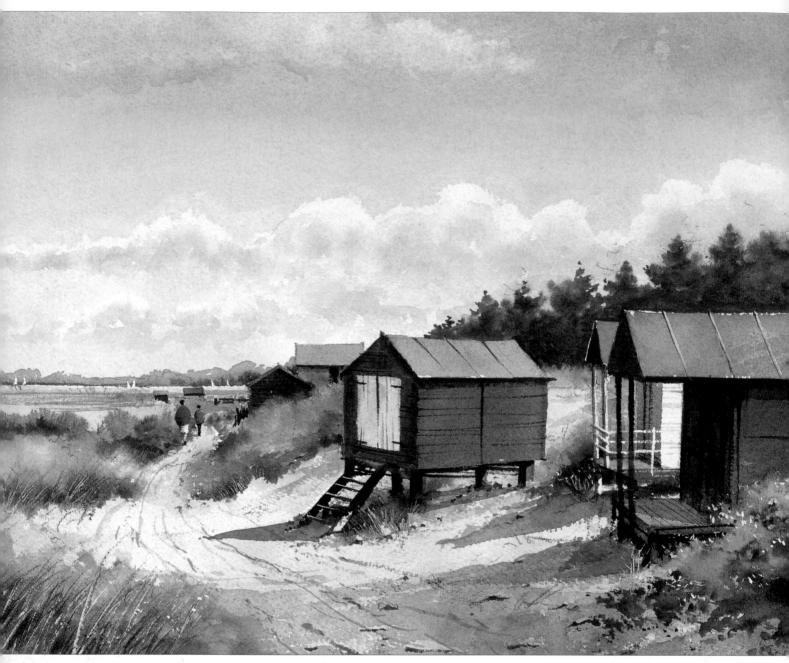

Beach Huts at Minehead

34 x 27cm (13½ x 10½in)

Whilst this is a totally different scene to that of Holmfirth, it shares the same basic idea, that we can create perspective by the position of the buildings. The suggested lines in the path through the sand help this effect. The viewer's eye follows the figures and is drawn towards the white and red sails in the far distance. Note how the rich dark green of the fir trees pushes forward the shapes of the beach hut roofs.

Boatyard at Woodbridge

340 x 270mm (13½ x 10½in)

Here the positioning of the boats leads the eye to the distant area just to the right of the whitewashed building. Note that the planks of timber at the bottom right plus the suggested lines on the yard also point to this area. There is no mistaking where we are meant to look in this scene.

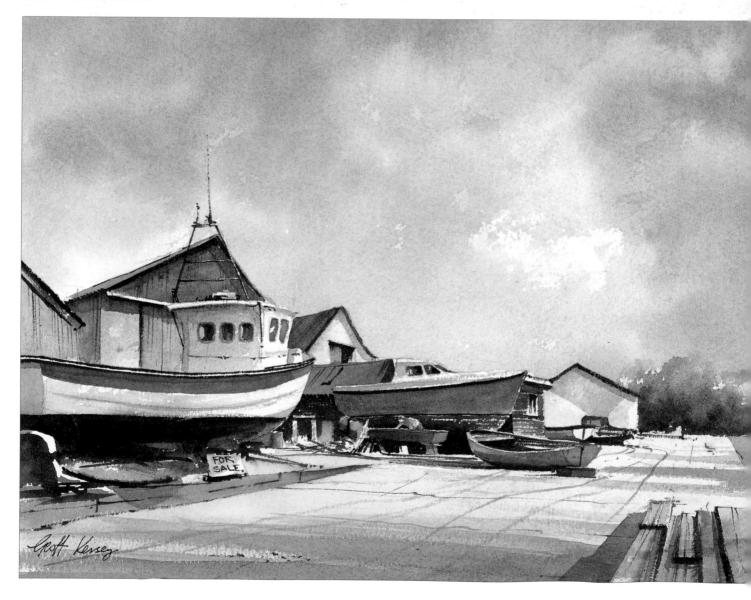

Snow Scene

The first few days of 2003 gave me some marvellous weather conditions for gathering painting subjects. There was a light coating of snow under crisp, bright, clear skies and I knew this scene was a painting as soon as I came across it, on a woodland walk in the Peak District.

I find that nature does not often give us a perfect composition, but I think this is one occasion where all the main aspects of the scene are perfectly placed. Our eye is led from the large silver birches on the left, along the winding path to the smaller birches and out into the distance, where we get a glimpse of the hills beyond the woods.

When I came across this scene on a New Year's day walk in the Peak District, I knew instantly that it was a ready-made painting and couldn't wait to get back to the studio to get cracking. A digital camera is ideal for such moments!

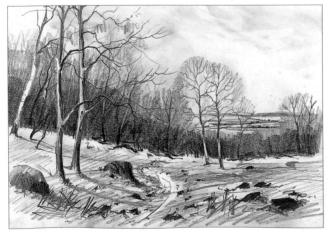

A quick pencil sketch like this helps to identify the basic elements and simplify the scene.

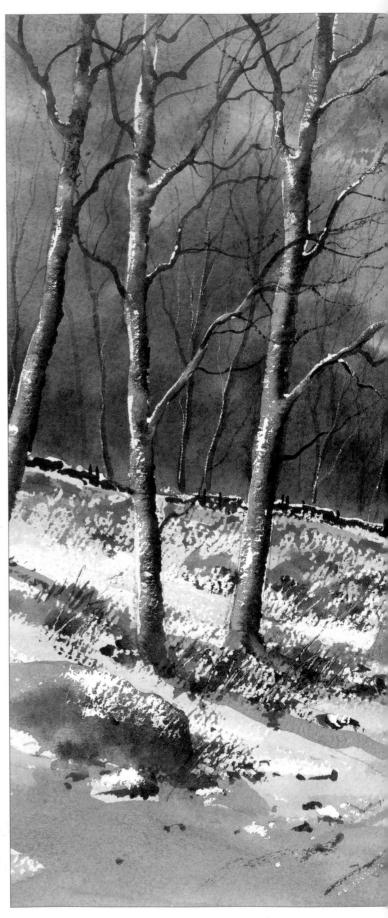

The finished painting

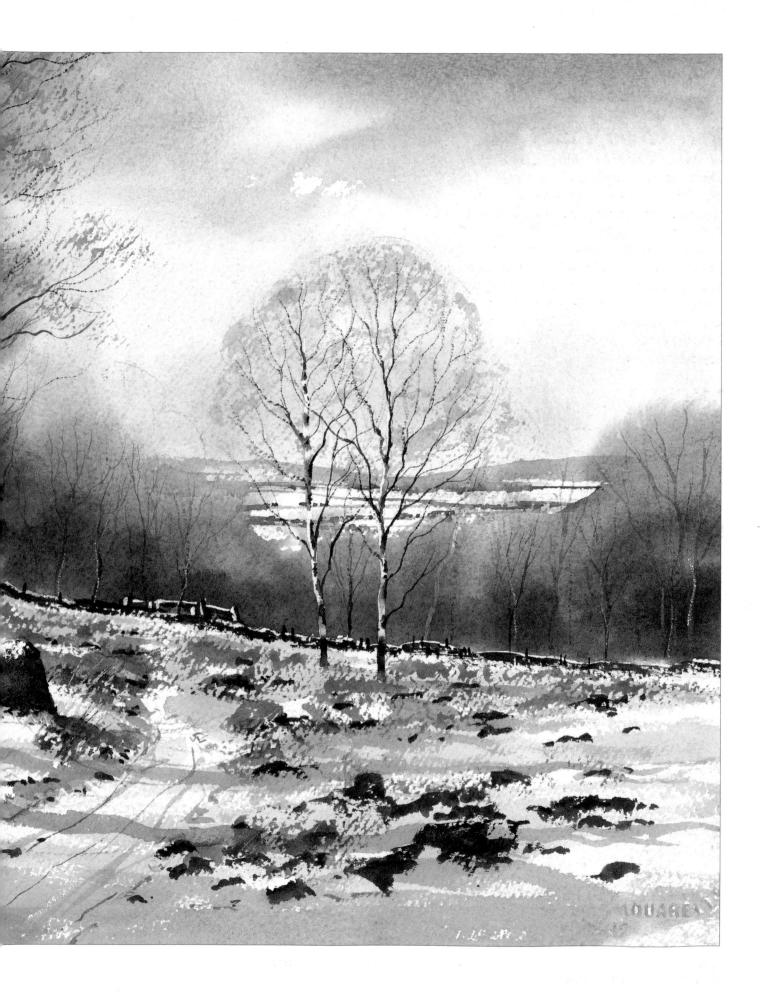

YOU WILL NEED Rough paper, 380 x 300mm $(15 \times 11^{3/4}in)$ Masking fluid Naples yellow Cobalt blue Cobalt violet Burnt sienna Raw sienna French ultramarine White gouache Old paintbrush 2.5cm (1in) flat wash brush Large filbert wash brush Round brushes: no. 12, no. 4, no. 16, no. 8, rigger

Craft knife

1 Sketch the scene and using an old brush, paint masking fluid on to the silver birches, the rocks in the foreground, the birches in the middle ground and the line where the snow meets the woodland.

2 Use a 2.5cm (1in) flat brush to wash clear water over the painting from the top to the horizon.

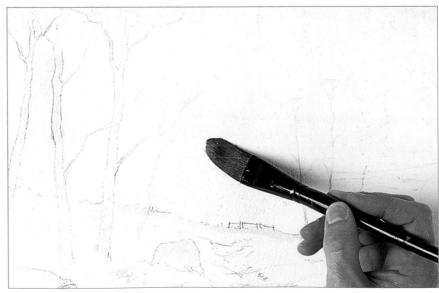

3 Using a large filbert wash brush, drop Naples yellow into the wet area in the lower part of the sky to create a glow.

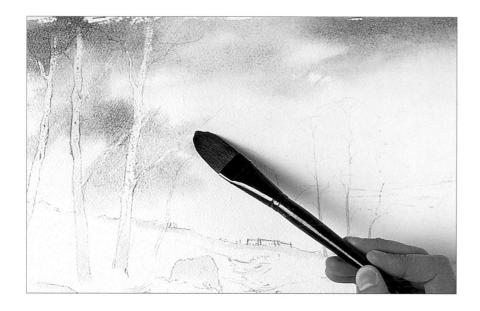

4 While the paper is still wet, drop cobalt blue and cobalt violet in at the top of the painting, down to about half way. The sky should be darker at the top, which gives the impression of perspective. Leave areas of white paper to suggest clouds. Add burnt sienna to the previous mix for a cloudy grey and drop this in.

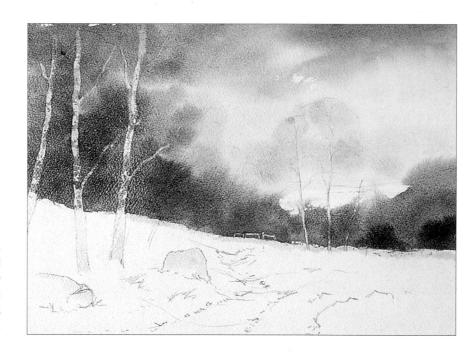

5 Drop in a thick mix of cobalt blue, cobalt violet and burnt sienna for the tree area. Use the side of the brush to suggest soft edges at the tops of the trees. Add raw sienna and burnt sienna for a red glow.

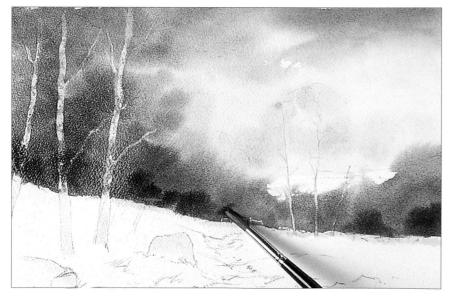

6 Working wet in wet, add cobalt blue and burnt sienna for the darker area at the bottom of the trees. Allow the painting to dry.

TIP

For dry brush work, hold the brush on its side with four fingers on one side and the thumb on the other so the side of the hairs just catches the raised area of the Rough paper.

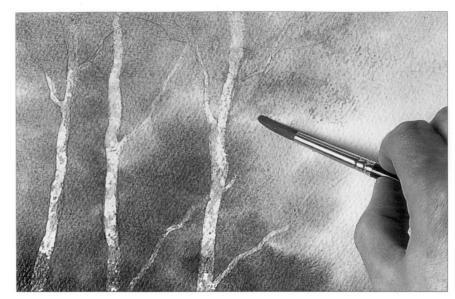

7 Use the side of a no. 12 round brush and the dry brush work technique to suggest the finer foliage at the ends of branches.

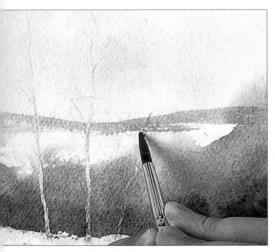

8 Mix cobalt blue, cobalt violet and burnt sienna, the colours that made up the grey and blue of the sky. With the no. 12 round brush, paint in the distant hills, wet on dry. The cool colours will make the hills recede into the background.

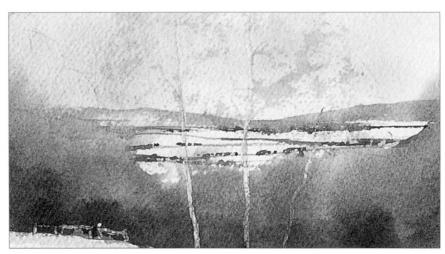

9 Using the same colour mix and the very tip of the no.12 brush, suggest the distant trees and dry stone walls. Use a little bit of dry brush work to emphasise the tops of the trees in the middle distance with raw sienna and burnt sienna.

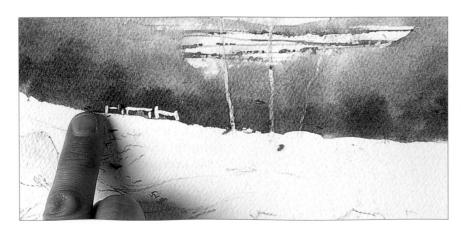

10 Rub off the masking fluid at the base of the treeline using a finger. Clean up with a putty eraser if necessary.

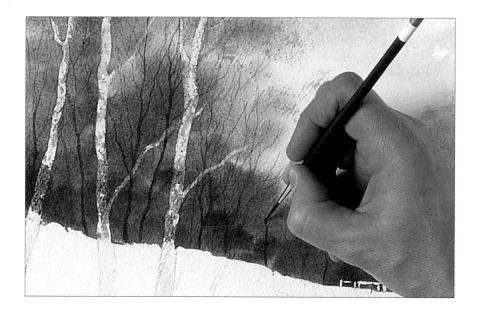

TIP

Rapid strokes of the brush look more convincing when painting trees in the distance. Always paint trunks and branches from the bottom upwards.

1 1 Mix a brown using cobalt blue mixed with burnt sienna, and with a no. 4 round brush, paint in distant tree trunks. Make some look further away by adding more water to the mix, and some nearer by using thicker paint. Use a rigger brush for finer branches.

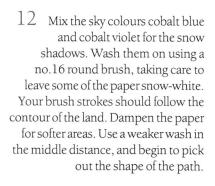

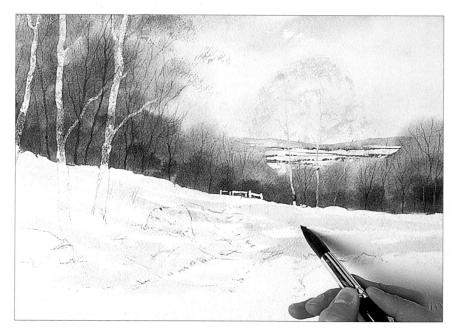

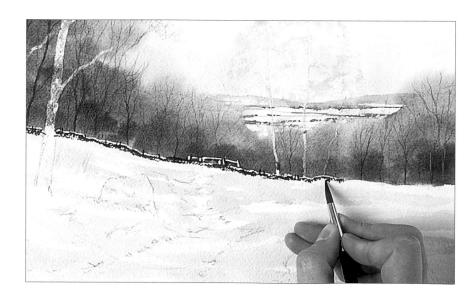

13 In the middle distance, develop the hint of a dry stone wall using a no. 8 round brush and a very dark brown mixed from burnt sienna and French ultramarine. The richer colour of the French ultramarine creates a richer, darker brown. Keep the brush fairly dry and use it to catch the texture of the paper, leaving a sharp white edge to represent snow on the top of the wall. Use the point of the brush for fence posts against the wall.

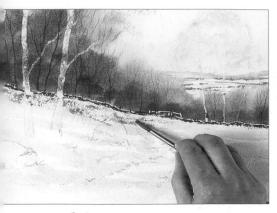

14 Make a thick mix of raw sienna and burnt sienna and use the side of a no. 8 round brush to catch the paper texture to indicate bracken in the snow.

15 Drop dark brown in to the red bracken while it is wet. The effect will be soft where the paint is wet and scumbled where it meets the dry paper. Scratch out the shapes of grasses and twigs using a craft knife.

The scratching out technique depends on good timing. If you scratch out when the paint is too wet, colour runs back in to the grooves; if you leave it too late, the dry paint will not scratch out. The best time is when the shine has just gone from the paint.

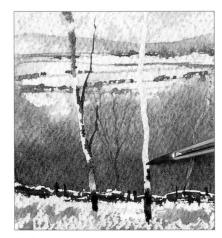

16 Rub off the masking fluid from the middle trees. Wet the trunks with clear water and drop in dark brown using a no. 4 round brush. The paint will spread into the wet area. To bring these trees forwards, the darks on their trunks should be darker than the background and the lights lighter.

17 Take a rigger brush and indicate the finer details of the branchwork.

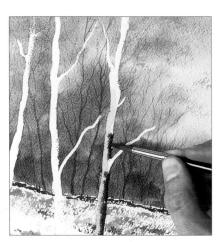

18 Rub the masking fluid from the foreground trees. Wet the right-hand trunk and drop in a mix of Naples yellow and raw sienna. Working wet in wet to avoid stripes, drop in a mix of cobalt blue and cobalt violet, then add a dark brown mixed from burnt sienna and French ultramarine on the right-hand side, since the light is coming from the left. Paint the finer branches in the same way using a rigger brush.

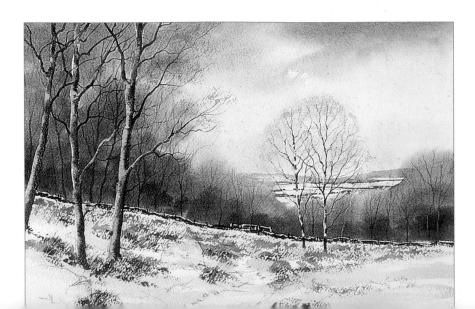

19 Work the remaining two foreground trees in the same way.

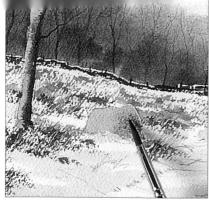

20 Rub the masking fluid off the large rock. Mix raw and burnt sienna plus a green from raw sienna and cobalt blue, and for the darker areas of stone mix burnt sienna and French ultramarine. For shadow use the sky colours, cobalt blue and cobalt violet. Mix all these colours wet in wet on the rock, leaving white for a hint of snow.

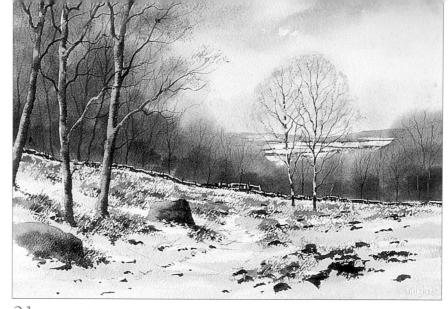

21 Paint the other rock in the same way. Use a no. 8 brush and dark brown to suggest stones sticking up through the snow. Make these larger nearer the foreground to help the perspective.

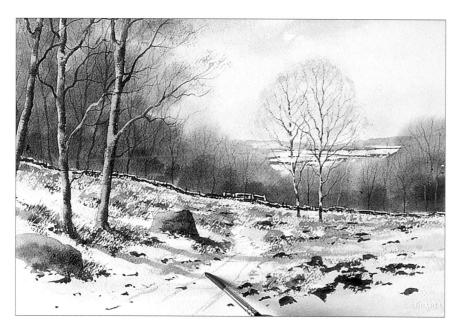

22 Paint the shadows in cobalt blue and cobalt violet. It is important that the paint is transparent so that the colours underneath show through. Put in long shadows for the left-hand trees to emphasise the direction of the light.

23 Paint in shadows to suggest trees beyond the left-hand edge of the picture casting shadows into the scene, and indicate the ruts in the path to create linear perspective. Make your marks stronger near the foreground, which creates aerial perspective. Take a no. 16 round brush and add more of the same colour to bring the foreground forwards. Soften any hard edges with a damp, clean brush.

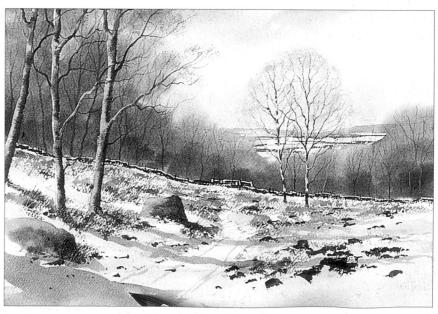

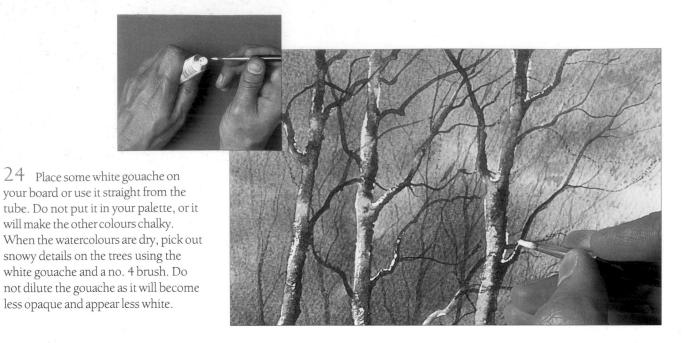

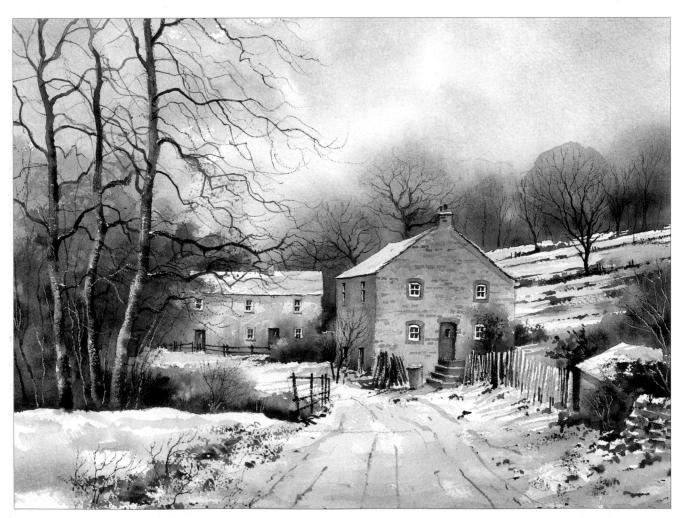

Winter in Padley

 35.5×27 cm $(14 \times 10^{1/2}$ in)

This is one of my favourite areas in the Peak District; I must have painted here dozens of times. The main blue in the sky and in the shadows is cerulean; this is quite a cold colour and really injects a wintery feel into the scene, especially when combined with the milky sunlight effect in the lower part of the sky, suggested with a thin wash of Naples yellow. Note how the shadows have been indicated with the same cold blue, warming it slightly with a touch of rose madder in the foreground to bring it forward.

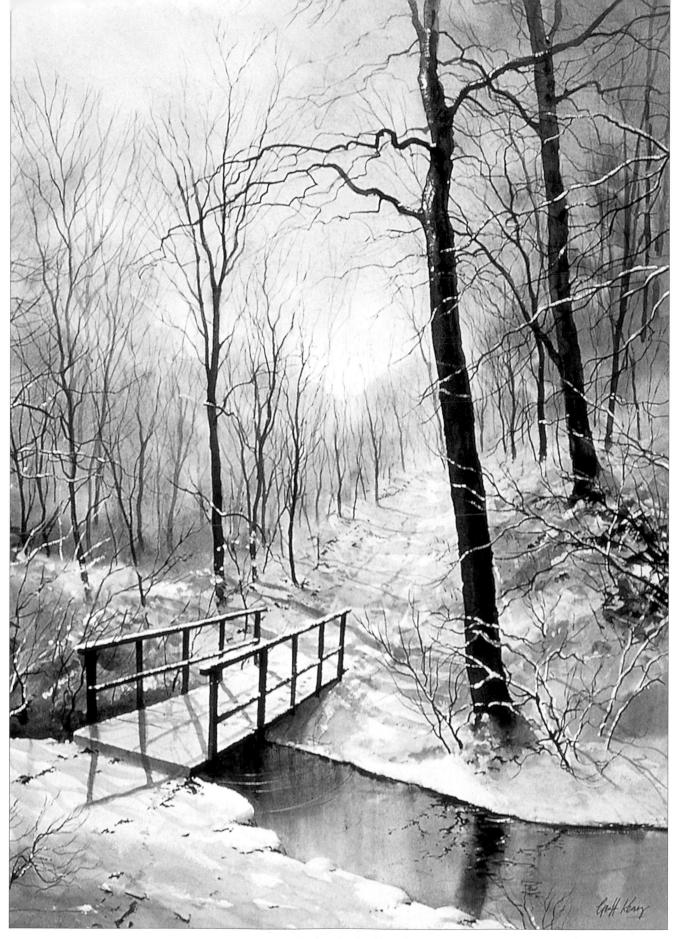

Foot Bridge in the Woods

530 x 750mm (21 x 29¾in)

This is a little hidden location twenty minutes' walk from my home. The light was perfect on this cold winter's afternoon with that beautiful red glow, which I recreated with thin washes of Indian yellow and cadmium red. Note the aerial perspective created by rendering the more distant trees in cooler colours and lighter tones.

Glencoe

This atmospheric scene from the Highlands of Scotland is a good illustration of how to combine aerial and linear perspective to create a feeling of distance in a painting.

The linear perspective is simply the path of the river winding into the composition. Note that it disappears out of view, leading your eye to the focal point to the right of the centre. Had this been dead centre it would have ruined the composition, dividing the paper down the middle. The aerial perspective is created by making the left-hand hills become gradually cooler in colour and paler in tone, creating the feeling of recession. The dark, shadowed hill on the right pushes back the distant hill behind it even further. Don't be afraid to use strong, dark colour when necessary. Being timid is the short-cut to mediocrity in a painting!

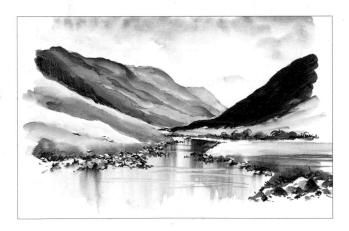

I felt that I captured this wild scene perfectly, with plenty of information contained in this sketch carried out with water soluble pencils. A few colour notes in the margin can also be helpful.

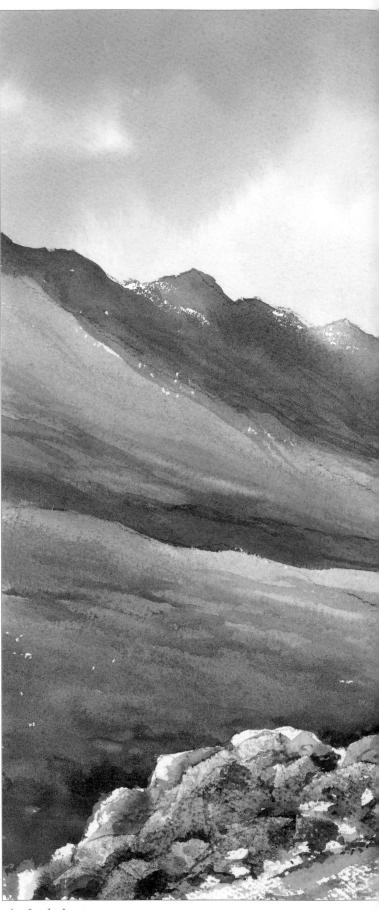

The finished painting

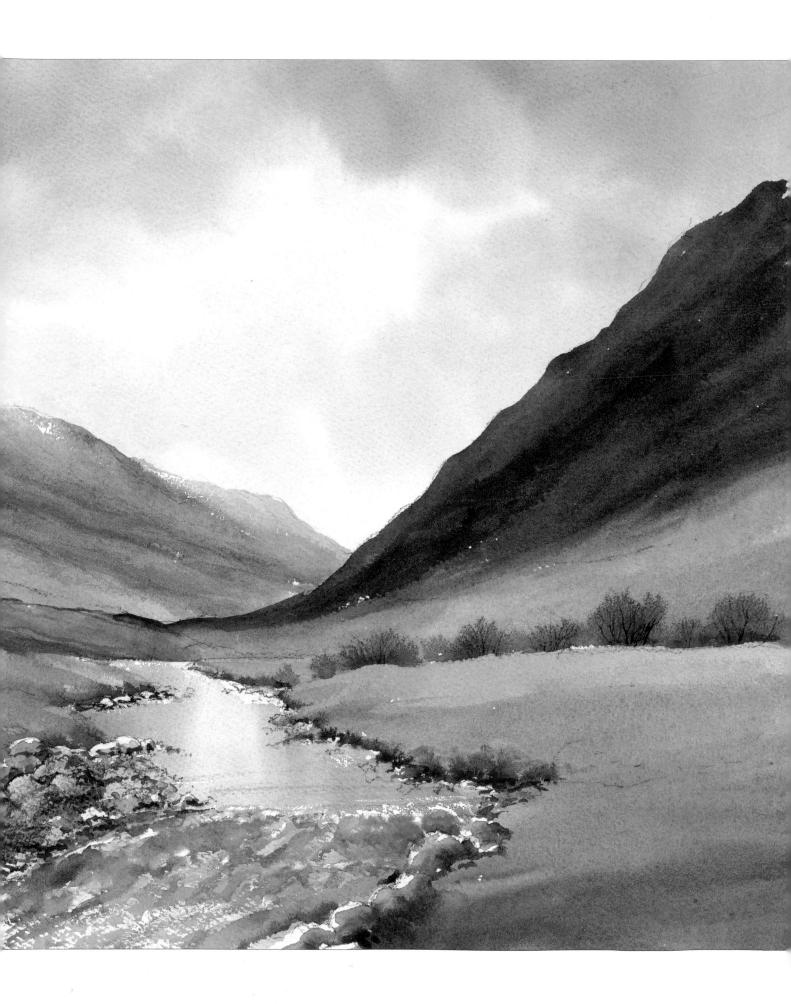

YOU WILL NEED

Rough paper, 490 x 350mm

 $(19\frac{1}{4} \times 13\frac{3}{4}in)$

Masking fluid

Sponge

Raw sienna

Cobalt blue

Neutral tint

Sepia

Burnt umber

Aureolin

White gouache

Old paintbrush

1 cm (1/2 in) flat brush

Large filbert wash brush

Round brushes: no. 16, no. 12,

no. 8, no. 4, rigger

Craft knife blade

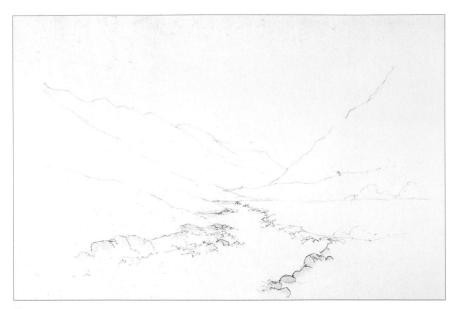

1 Use an old paintbrush to paint masking fluid on the line where the river bends out of view, and on the tops of the rocks and stones.

2 Mix four sky washes in advance so that they are ready for painting quickly: raw sienna, cobalt blue, neutral tint and finally sepia. Wash the sky area with clean water applied with a sponge, coming down below the tops of the hills.

3 Wash raw sienna on to the lower part of the sky, then carefully float in some cobalt blue. Don't swirl it around too much or you will create a green. Then add neutral tint towards the top, and finally sepia at the very top. This will make the sky considerably darker at the top and lighter towards the horizon, creating aerial perspective. Allow the sky to dry.

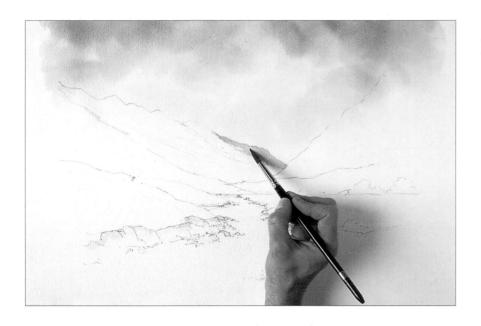

4 Using a fairly dry no. 12 brush, paint the distant hills in pale cobalt blue, greyed slightly with neutral tint.

5 Add burnt umber to the cobalt blue/neutral tint mix to warm it, and paint the middle distance using a no. 16 brush. Paint more cobalt blue and neutral tint at the top and a little raw sienna for more warmth at the bottom.

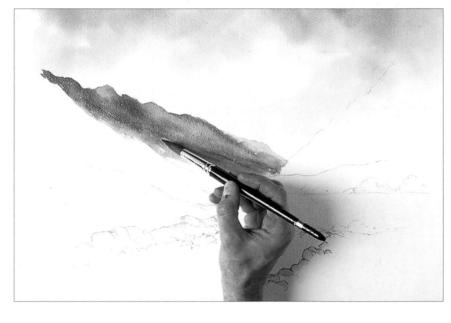

TIP
In a mountainous scene like this, it is important that your brush strokes follow the

contours of the land.

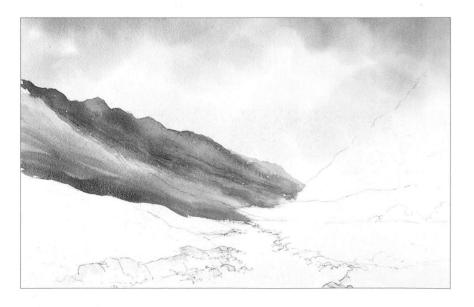

6 Add a green mixed from aureolin and cobalt blue. Wash cobalt blue mixed with neutral tint over this, working wet in wet to avoid making stripes. This will darken the area, to contrast with the lighter hill. Wash sepia on top to darken further. Add more cobalt blue and neutral tint to suggest dark cloud shadows. Allow to dry.

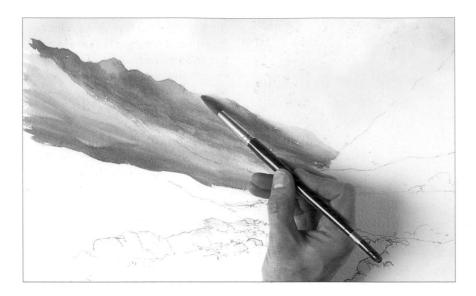

7 Brush the most distant hill with clear water fading it to push it further back into the scene. Make sure it is fully dry beforehand, or you will remove the pigment rather than just fade it. Using a no. 12 brush and cobalt blue mixed with neutral tint, add streaks. Use sepia to paint in the dark ravine, and fade the top using clear water again.

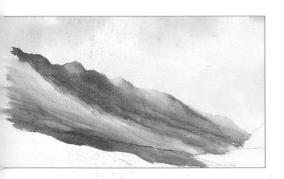

8 Use sepia to create crags and gullies on the left of the green area, and neutral tint with cobalt blue to reinforce the darks, for greater contrast with the lighter hill. Streak in the darker paint with a dry brush to give the land a rough look.

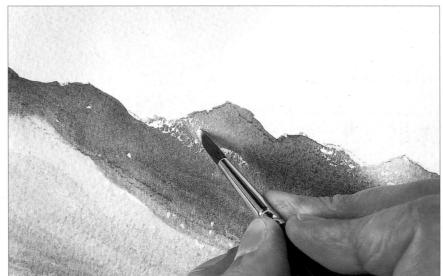

9 Using neat white gouache straight from the tube, catch the surface of the Rough paper very lightly on the tops of the hills to suggest snow. You can use a damp brush in one or two places to lighten the gouache.

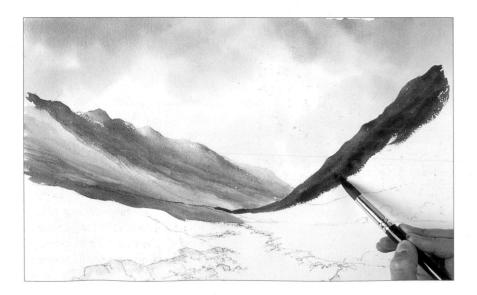

10 Paint the dark hill on the right using a no. 16 brush and a mix of burnt umber with neutral tint. This must be strong enough to make the distant hill behind it appear to recede, so cover all the white paper.

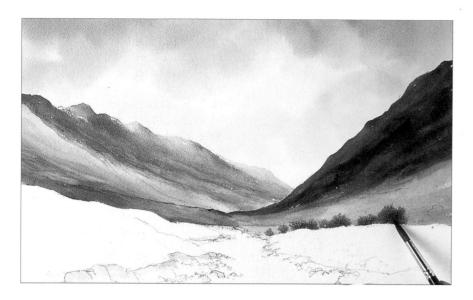

11 Carry on down the hill painting wet in wet and bringing in raw sienna for brightness and a touch of green mixed from aureolin and cobalt blue. To paint the stand of trees on the right of the painting, mix burnt umber and neutral tint and drop soft shapes into the wet paint. Use the same dark paint to darken the upper part of the hill on the left, to create contrast with the lighter part to come. Allow to dry.

12 Make a thin wash of raw sienna for the brightness on the left-hand middle ground. Paint a stronger mix of raw sienna and burnt umber on top, softening it into the contrasting dark above it. Add cobalt blue and neutral tint to darken the area in streaks. Bring in some green mixed from aureolin and cobalt blue.

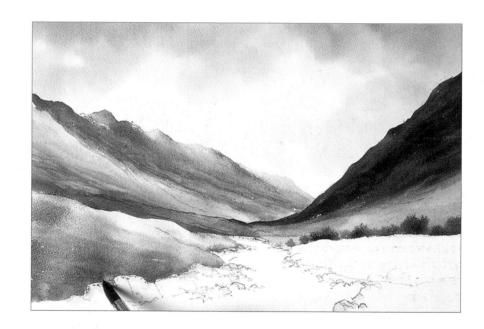

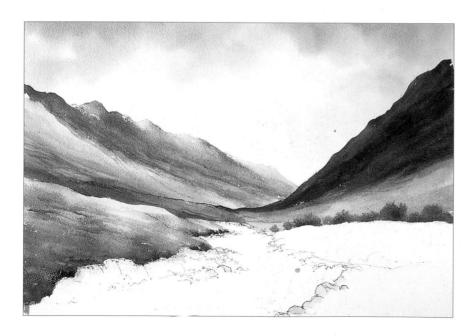

13 Use a dry brush with burnt umber to paint streaks of dark into this triangle of land, to give it a patchy look. Take a no. 8 brush and use a dark mix of burnt umber and neutral tint for the dark areas of soil where the land meets the water, allowing this to drift into the lighter colour above it.

14 On the right-hand side of the river, wash on raw sienna to contrast with the dark hills. Add raw sienna and burnt umber to give a warm brown tint. Mix green from aureolin and cobalt blue. Paint raw sienna, burnt umber and green towards the foreground, leaving spaces for stones. Use burnt umber and neutral tint for the dark patch at bottom right. Paint dark brown for the soil at the river's edge.

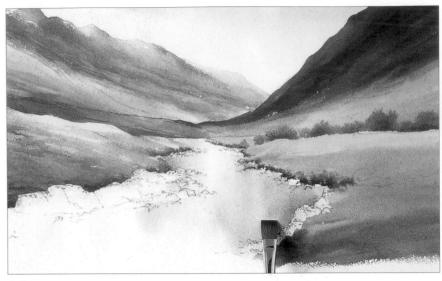

15 Rub off the masking fluid from where the river bends out of view. The river is painted in two parts; firstly the slow flowing part that reflects the sky. Take three separate washes: cobalt blue, neutral tint and raw sienna. Wet the reflective river area with clean water down to where the river rushes, then float the three colours into this wet background. Immediately, using a $1 \, \text{cm}$ (½in) flat brush, drag the colours down vertically to the stones. Allow to dry.

16 Rub off the masking fluid from the stones. Take a no. 4 brush for the smaller stones and a mix of burnt umber and neutral tint and work the shapes of the stones. Make tiny marks to create form – do not attempt to draw round the stones, or they will look flat.

17 Wet the area of the stones in the middle ground. Make a thin wash of raw sienna and float it in, then drop in cobalt blue on top, and neutral tint on top of that. Make a very dark mix of burnt umber and neutral tint and drop that in wet in wet. Take a craft knife blade and move the colours around by scraping it over the paper, using the flat of the blade to create form and texture.

18 Take a no. 4 brush and mix a dark shade of burnt umber and neutral tint. Work this dark into the rocks to emphasise their shape. Allow the painting to dry.

TIP

It is important to use colours for the stones that have already been used elsewhere, or the stones will look as if they belong in another painting.

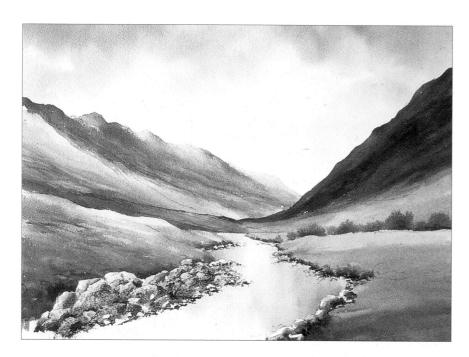

19 Paint some of this dark brown into the rocks in the foreground and allow to dry once more.

20 Find the horizontal line in the painting where the water begins to run downhill. Drop in a little neutral tint and sepia, then take a no. 8 brush and use white gouache straight from the tube, adding this while the watercolour is dry in some parts, wet in others, to suggest foam. The white gouache can also be used to suggest splashes and add horizontal lines in the water.

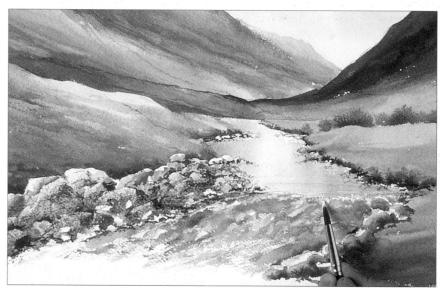

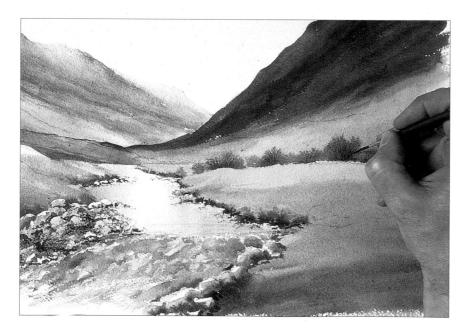

21 Develop the shapes of trees using a rigger brush and burnt umber mixed with neutral tint to indicate the branches. Paint the trees, as always, from the bottom up.

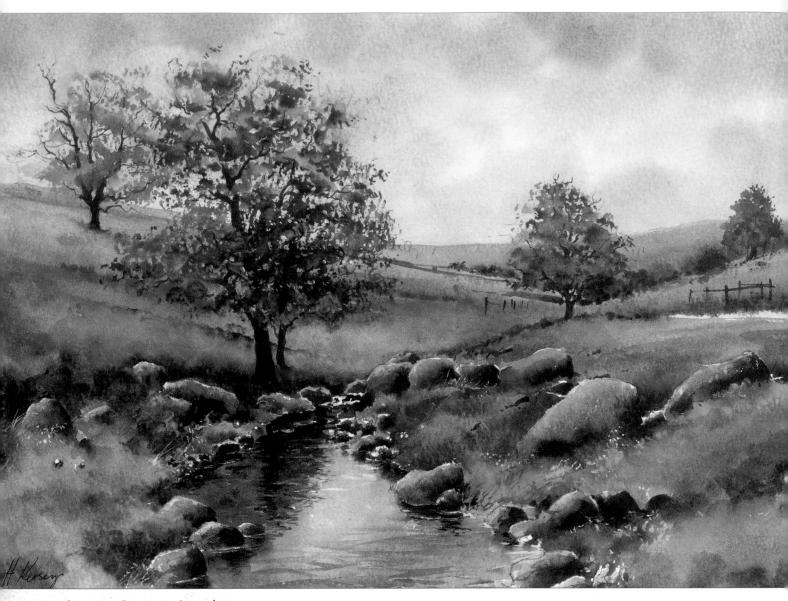

Stepping Stones in Longshaw

406 x 292mm (16 x 11½in)

The bright afternoon light in this scene, created with a mix of cobalt violet, raw sienna and burnt sienna, contrasts well with the rich darks in the shadows and reflections. Don't just think of water as blue; it reflects all the colours around it. To help this effect it is a good idea to write down the colours you are using, so that when you come to painting the water, you can remember the colour mixes and match them.

Watendlath Beck, Cumbria

420 x 292mm (16½ x 11½in)

A beautiful location with a paintable view in every direction. It has all the right ingredients: a packhorse bridge, rustic old farm buildings and a shallow beck or stream leading to a still mountain lake, all set to a backdrop of the Cumbrian hills. All elements in the scene lead the viewer to the focal point of the bridge. Note the person on the bridge wearing red which catches the eye, and how the tonal value of the hills is reduced as they recede into the distance. You don't have to work too hard on rocks and stones: observe how simply they have been treated here — just as areas of light and shadow.

Boats at Bosham Quay

In this painting the distinctive shape of the Saxon church across the water makes an excellent focal point. Note how this is a third of the way into the picture, always a good position compositionally. The cluster of boats make excellent foreground detail, but note how I have reduced the number of these and altered their positions slightly. You don't have to copy slavishly what is on your photograph; you should take some time at the outset to consider any changes or simplifications you wish to make. I have found that most picture buyers, even if they are familiar with the location, expect you to use some artistic licence.

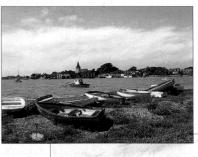

I took many shots of this scene, as I often do, to give me plenty of choice back at the studio. I chose this one for the jumble of boats that added a lot of interest to the foreground.

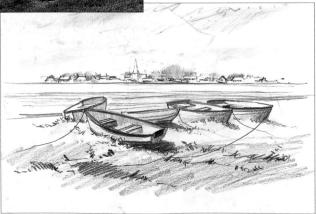

Before setting about the finished painting, I used a quick pencil sketch to simplify the foreground, deliberately not including all the boats. What to leave out and what to put in is a personal decision and one you have to get into the habit of making yourself.

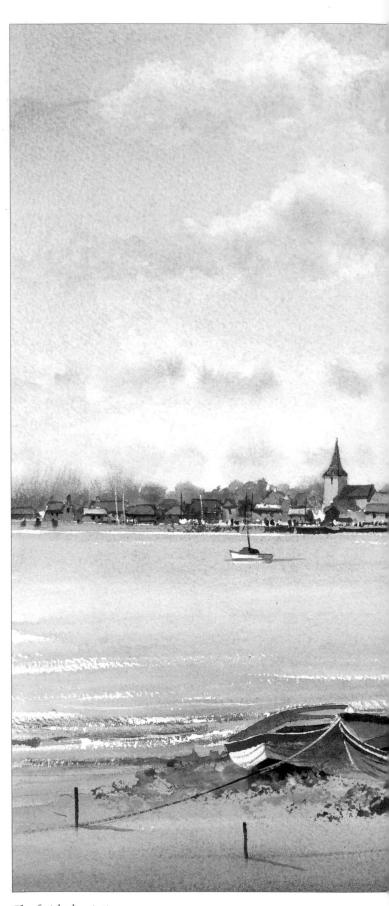

The finished painting

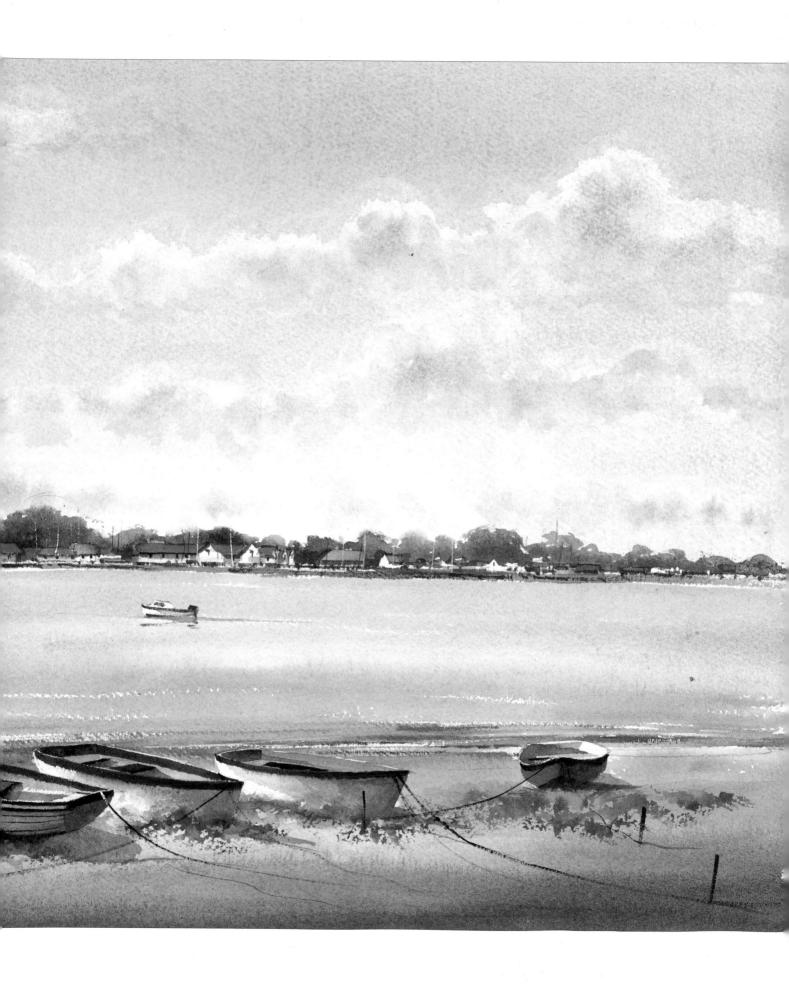

YOU WILL NEED

Rough paper, 550×370 mm ($21\frac{3}{4} \times 14\frac{1}{2}$ in)

Masking fluid

Cobalt blue

Cobalt violet

Cerulean blue

Aureolin

Viridian

Burnt sienna

Raw sienna

French ultramarine

Cadmium red

Naples yellow

Burnt umber

Lemon yellow

White gouache

Old paintbrush

Large filbert wash brush

Round brushes: no. 8, no. 4, no. 16

Kitchen towel

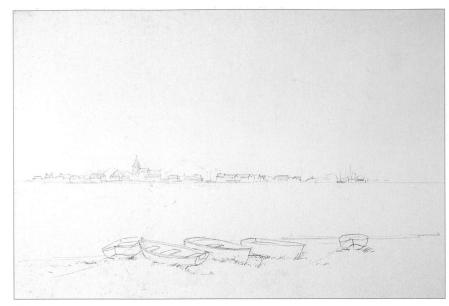

 $1\,$ Sketch the scene and use an old paintbrush to apply masking fluid to the rooftops of the buildings across the estuary. Do not mask the boats yet, or your hand will disturb the masking fluid as you work on the top of the painting.

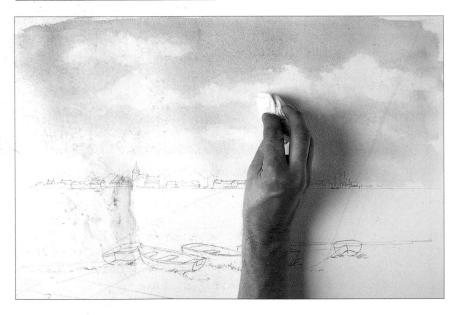

2 Mix two washes for the sky: cobalt blue with cobalt violet for the top of the sky and cerulean blue for the lower part of the sky. Using this colder blue near the horizon will make it look further away, helping the aerial perspective. Wet the sky area and paint on the washes wet in wet using a large filbert wash brush. Immediately dab areas with a kitchen towel to suggest clouds. Allow the painting to dry.

TIP

Make the cloud shapes smaller nearer to the horizon to create a feeling of distance.

3 Now work on one cloud at a time, re-wetting each one with clear water then dropping in a cloud shadow colour mixed from cerulean blue and cobalt violet. Move on to other clouds and work them in the same way. Continue softening the clouds with clear water to prevent hard lines from forming; you are trying to achieve a soft, vaporous look. Allow to dry.

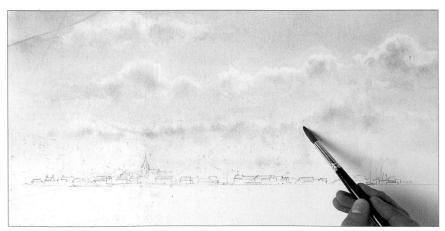

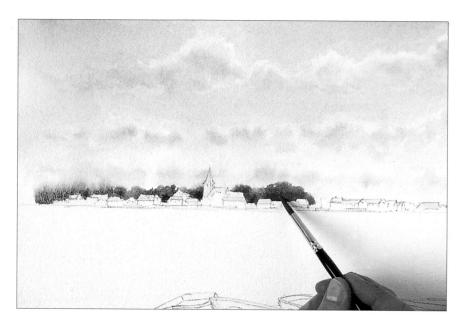

4 Mix cobalt blue and cobalt violet with aureolin. Take a no. 8 brush and paint vague tree shapes in the distance. Before they are dry, soften the edges with a clean, damp brush to make them recede into the distance. Make some trees softer and leave others with harder lines for variety. Drop viridian and burnt sienna into one or two of the tree shapes to make them bolder.

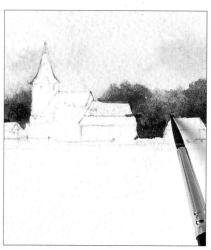

5 Remove the masking fluid from the rooftops. You may need to tidy up some of the edges using background colour and a no. 4 brush.

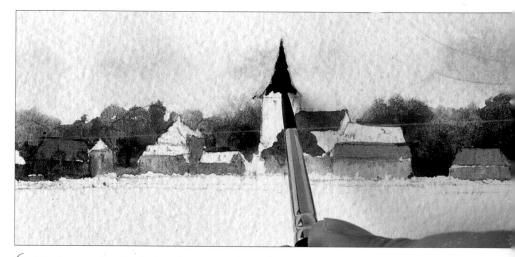

O Mix four washes for the buildings: aureolin and burnt sienna for the roofs; raw sienna; burnt sienna and cobalt blue and burnt sienna with French ultramarine for darker details. Paint shapes for the roofs and buildings: you are not looking for accuracy but for general rectangular shapes which will suggest walls and rooftops. Use the dark brown for shadows and to paint the suggestion of windows with a dash of the no. 4 brush. Mix two greens: viridian with burnt sienna and aureolin with cobalt blue, and drop in trees in front of the buildings. Paint the church steeple in a midbrown made from cobalt blue and burnt sienna.

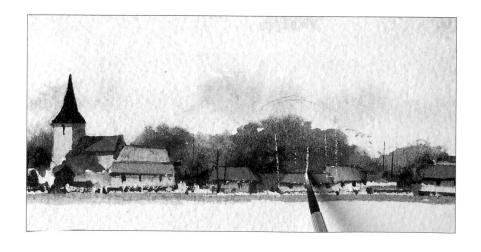

7 Continue to paint finer details with the dark brown mix and the shadow on the right-hand side of the church. Paint masts using white gouache straight from the tube. Add a few small shapes to represent vehicles on the road and boats on the quayside using bright colours such as cadmium red and cerulean blue, don't try to render these in any great detail—a suggestion is far more interesting.

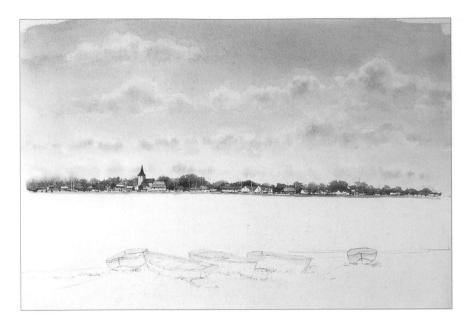

8 Paint masking fluid on to the top parts of the boats so that you can paint the sea and sand washes behind them without losing the shapes. It is important to stand back and have a good look at a painting at stages along the way. At this point I decided that the distance looked too sharp, which reduced the effect of aerial perspective. If this seems a problem, take a mix of cerulean blue and cobalt violet, like the one used for cloud shadows, and paint a haze over some of the background. Leave the church sharp and clear so that it remains the focal point of the painting.

Mix washes for the water. The water will show some reflection of the sky colours, so you will need cerulean blue with cobalt violet. However, the water will be greyer than the sky, so make another wash of cobalt blue and cobalt violet, but grey it using burnt sienna. Take a no. 16 brush and paint the cerulean blue and cobalt violet wash at the top of the water area in quick horizontal strokes, catching the surface of the paper so that some white shows through. Leave a tiny white line at the quayside. While the paint is wet, drop the greyer colour in wet in wet. Add raw sienna to warm the foreground and to suggest a glimpse of sand showing through the water.

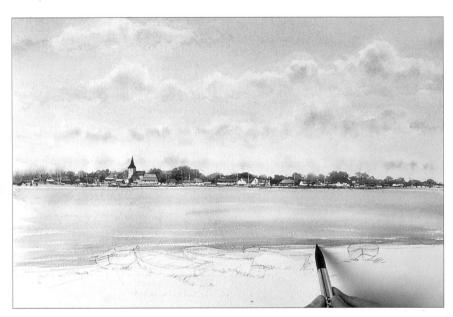

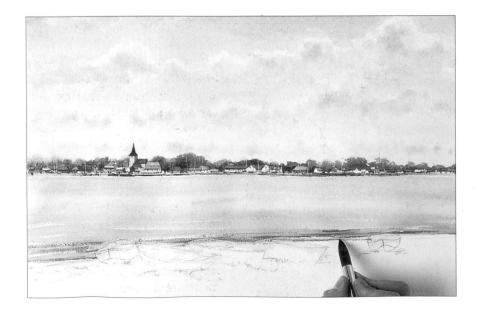

10 Leave a little white paper at the water's edge to suggest foam, and add a little dark shadow underneath using cobalt blue and burnt sienna.

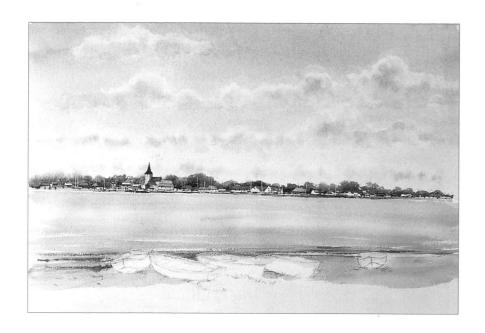

11 Paint the sand between the boats using Naples yellow mixed with burnt umber and a little cobalt violet. Fade the edge with clear water to avoid a hard line forming later. Allow to dry, then rub the masking fluid off the boats.

12 Start to build up the boats using a no. 8 brush and some fairly bright colours: burnt sienna and burnt umber; cerulean blue; raw sienna; burnt sienna and French ultramarine for darker details and cobalt blue and cobalt violet with a little burnt sienna for shadows.

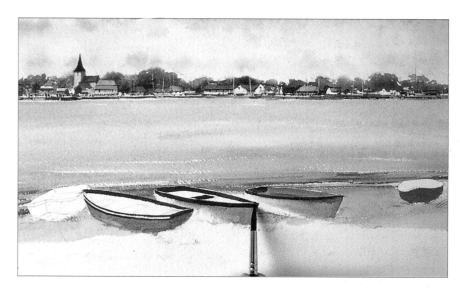

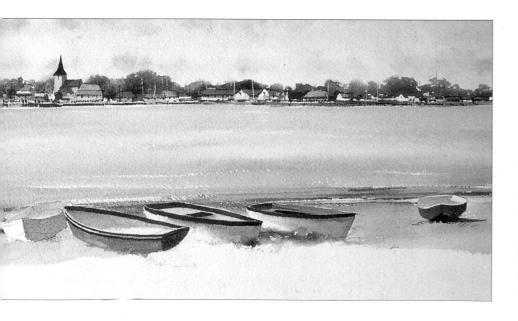

13 Continue building up the boats. Bear in mind that the light is coming from the left, so some white paper can be left on this side for highlights. The shadows should be painted using the sky colour cobalt blue and cobalt violet; they should be transparent so that the boat's colour shows through, and they should be more intense further away from the light. Paint the insides of some of the boats with a thin grey wash and add shadows. Add a dark brown mixed from burnt sienna and French ultramarine for the tar on the base of the boats.

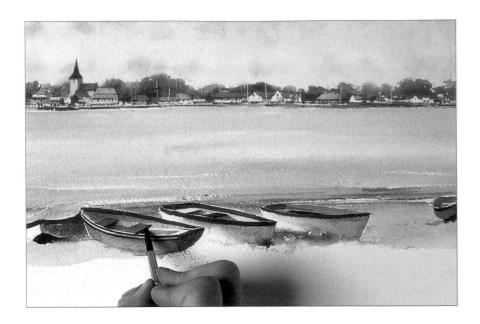

14 Continue building up the insides of the boats, using your reference photograph for details. Use French ultramarine for the rim of the left-hand boat. Work wet on dry, waiting for one colour to dry before carrying on with that area. Paint round the seats in the foreground boat and place dark brown shadow underneath them.

15 Some of the boats in the photograph where made from fibreglass, but it adds interest if you paint them as clinker-built boats, made from overlapping planks. Suggest this using swift strokes in the same dark brown. Paint the boats in the harbour in less detail, using white gouache with cerulean blue for the left-hand boat and with burnt umber for the right-hand one. Touch the bottoms of the boats in white gouache to place them in the water. Use the same gouache for the highlights on the foreground boats, the waves at the water's edge and for the ropes where they cross a dark background.

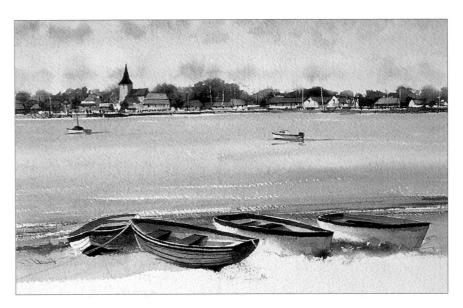

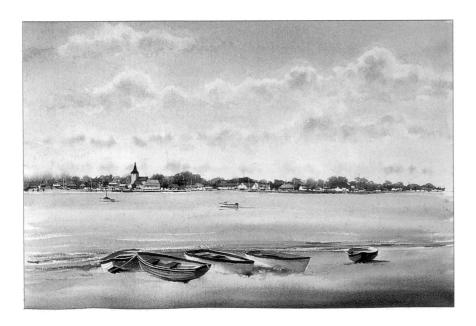

16 Mix Naples yellow and burnt umber with a hint of cobalt violet for the foreground sand. Use a no. 16 brush to sweep the sandy wash across. At the bottom edge add burnt umber and cobalt blue so that the foreground is darker, thus bringing it forward.

17 Dampen the sides of the boats and use a no. 8 brush and lemon yellow to suggest greenery growing round the boats. Drop a dark green mixed from viridian, French ultramarine and burnt sienna on top. I have painted less greenery than actually appears in the reference photograph, because I like the colour of the sand.

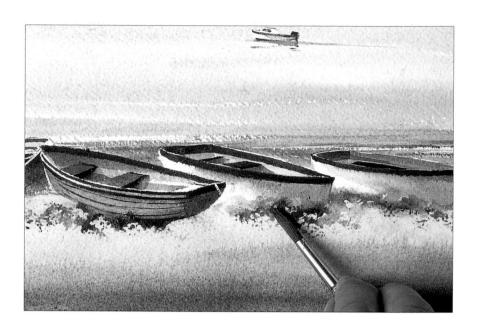

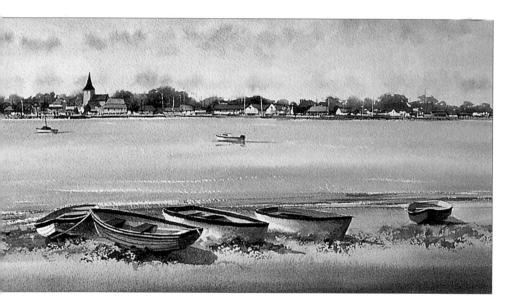

18 Paint the shadows cast by the boats in cobalt blue and cobalt violet. Soften the shadows into the hulls of the boats. Darken the weed around the extreme left-hand boat to contrast with the light tone of the hull.

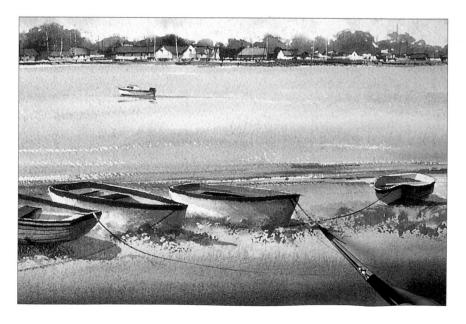

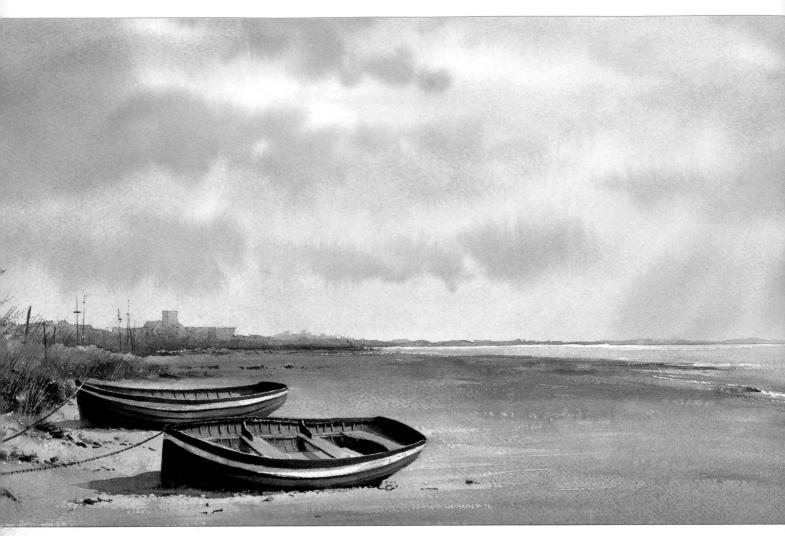

Gibraltar Point, Lincolnshire

508 x 330mm (20 x 13in)

Just a three mile walk along the beach from the hurly-burly of Skegness on the Lincolnshire coast lies this quiet stretch of beach where all you can hear is distant birdsong. A scene like this is three quarters sky, and it presents the watercolourist with a marvellous opportunity to create atmosphere. The sky is painted with three separate washes: Naples yellow with rose madder, a mix of cerulean and cobalt blue and a wash of neutral tint with just a touch of rose madder. I sloped the paper slightly and floated the washes into a wet background, determined to work on it very quickly then leave it alone to perform its magic. There were no boats on the sand — I cheated by adding these from a separate sketch.

Staithes, Yorkshire Coast

460 x 305cm (16 x 12in)

A Mecca for artists, this little coastal village with its weathered cottages and jumble of outbuildings is a world away from Bosham, the scene of the main painting in this chapter. This has been painted with a limited palette of six colours. Note the light against dark in the left-hand third of the scene, where the road disappears out of view. This is a really bright area that gives the painting a glow and draws the viewer's attention.

Cromford Canal

This little stretch of canal near Matlock Bath in Derbyshire, now a favourite spot for weekend walkers, was once the main transport route to and from a cotton mill, representing a significant part of the North of England's industrial heritage.

I love painting scenes like this where the initial stage consists of laying in a series of wet in wet washes, loosely forming the shapes of the foliage. The key to this scene is simplification. If you try to copy every bit of foliage too literally, the result will look crowded and overworked. Your aim should be to capture the essence of the subject.

When you are presented with the mass of foliage and jumble of branches, a scene like this seems a daunting prospect, but doing the pencil sketch really starts you thinking about how you can simplify. What to leave in and what to leave out? I created the feeling of reflections in the water simply by running a putty eraser over the sketch in vertical strokes.

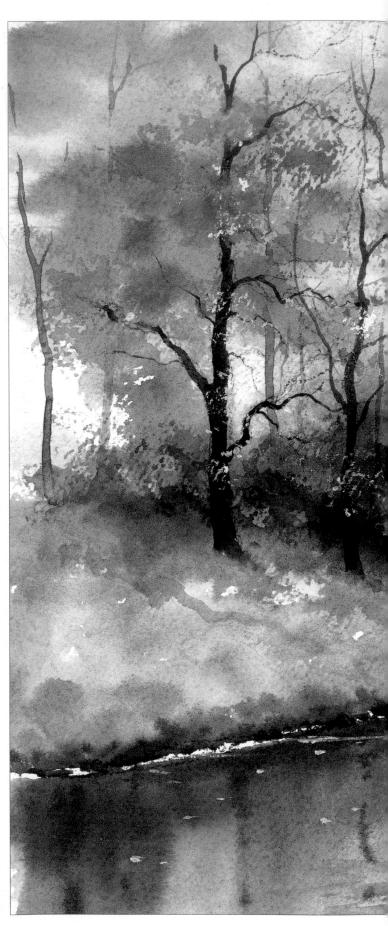

The finished painting

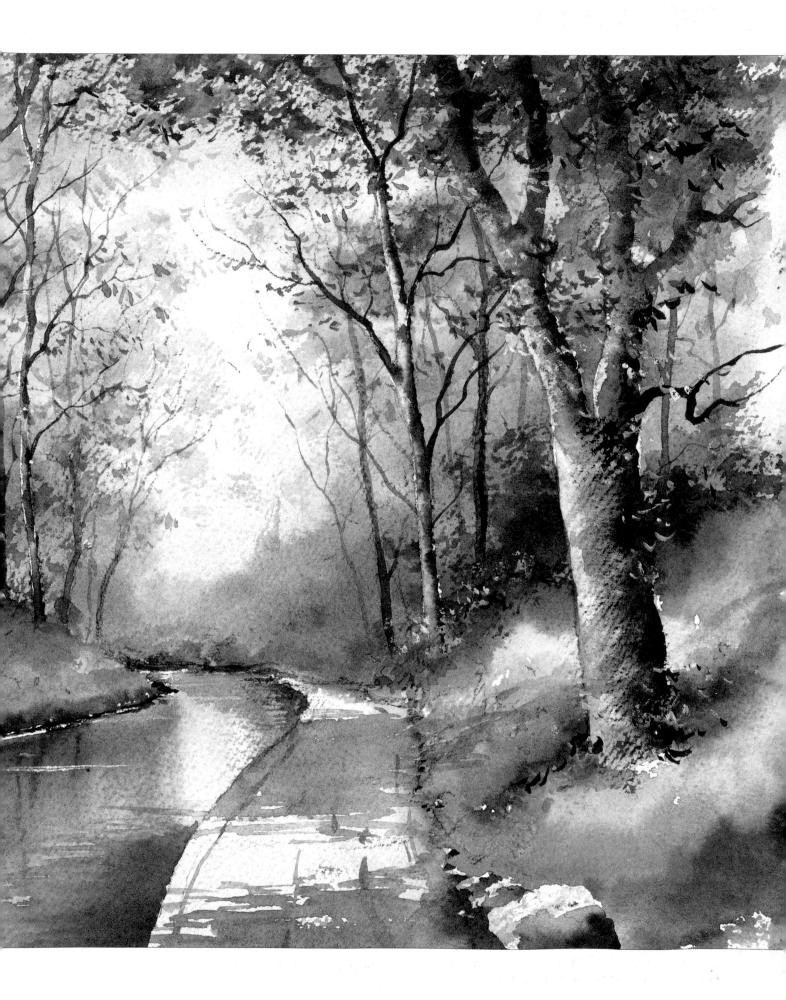

YOU WILL NEED

Rough paper, 360 x 270mm

 $(14\frac{1}{4} \times 10^{3}/4in)$

Masking fluid

Cobalt blue

Rose madder

Naples yellow

Lemon yellow

Aureolin

Viridian

French ultramarine

Burnt sienna

Cobalt violet

Raw sienna

Indian yellow

White gouache

Old paintbrush

2.5cm (1in) flat brush

1 cm (½in) flat brush

Round brushes: no. 12, no. 10,

no. 8, no. 4, rigger

Kitchen towel

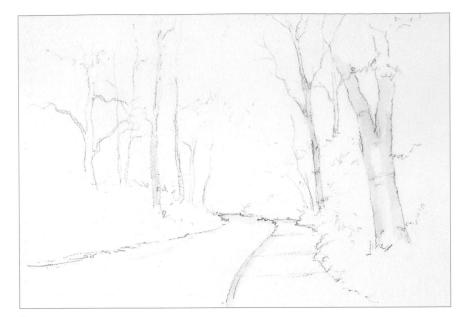

1 Draw the scene. Using an old paintbrush, apply masking fluid to the edge of the path to protect it later when you paint the water. Mask the large tree and one or two tree trunks where the trunk will be lighter than the background.

2 Much of the background will be painted in one go, floating colours on to wet paper. Mix seven washes before you start: 1) cobalt blue and rose madder; 2) Naples yellow and rose madder; 3) lemon yellow; 4) green mixed from aureolin and cobalt blue; 5) Naples yellow and lemon yellow; 6) viridian, French ultramarine and burnt sienna; 7) viridian and cobalt blue. Wet the paper down to the ground with a 2.5cm (1in) flat brush. Wash on cobalt blue and rose madder at the top, then Naples yellow and rose madder to create a pale pink glow in the lower part of the sky.

3 Float in a wash of lemon yellow followed by a mixture of lemon yellow and Naples yellow. If these look a bit too acid at first, don't worry; the colour will change as the later washes fuse in with them.

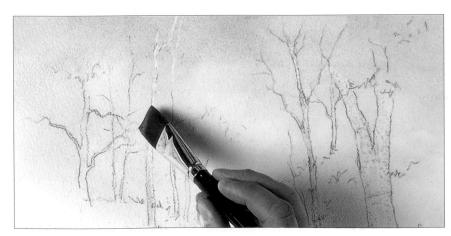

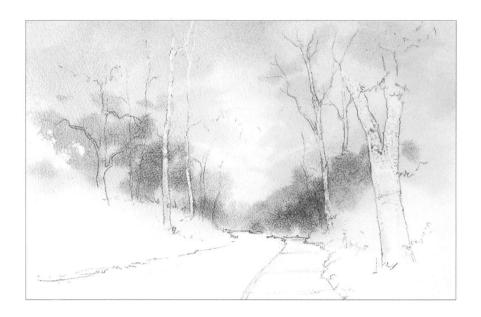

4 Still using the 2.5cm (1in) flat, continue adding colours, working light to dark. Add the green made from aureolin and cobalt blue. Change to a no. 12 round brush and add rose madder and cobalt blue for the browner colour near the ground. Add more green wet in wet.

5 Add the deep green made from viridian and cobalt blue. It will mix with the other colours on the page. Where a rich, dark green is required, add viridian, French ultramarine and burnt sienna.

Use the side of your no. 12 round brush to make shapes to suggest foliage.

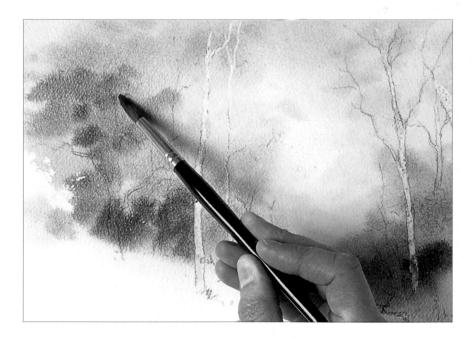

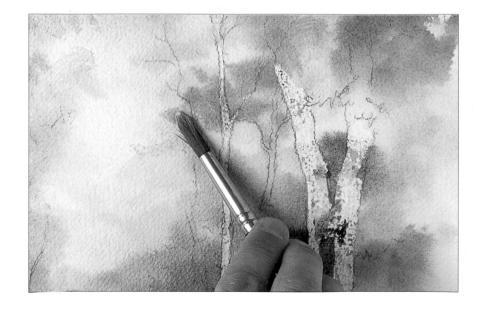

TIP

When working on the trees, take some detail from the reference photograph but do not try to make an accurate copy of it. Remember, the key to a scene like this is to simplify it.

6 Still working on the damp background, take a no. 10 brush and more bright green. Use dry brush work so that some of the marks look dry and others blend in for variety.

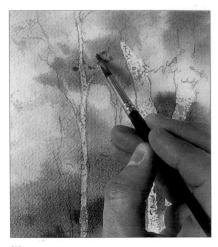

7 Continue with the same technique using viridian and cobalt blue. Take a no. 8 brush and work the shapes at the edges of the branches using aureolin and cobalt blue. At this stage the shapes begin to look like leaves and the washes should suggest tree shapes.

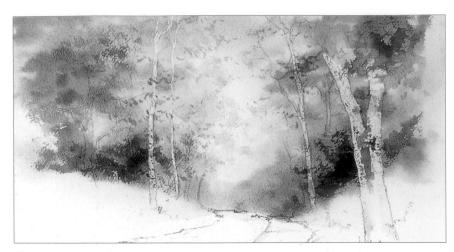

8 Apply the dark green in the same way. The darkest greens should appear at the base of a tree. Use cobalt blue and rose madder for the purplish foliage at the top right and far left.

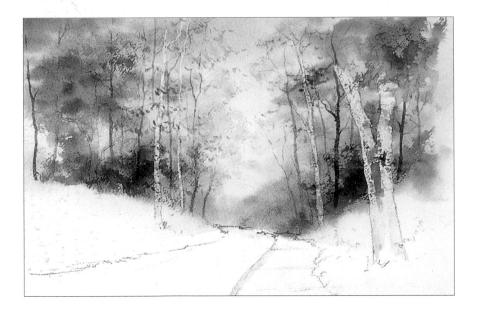

9 Paint the distant tree trunks with a mix of cobalt blue, rose madder and burnt sienna, working upwards with a no. 8 brush. Use a lighter version of the mix for faraway trees, and paint some of them with the side of the brush and the dry brush technique to add to the distant feel. Use the same colour at the centre of the painting over the bend in the canal.

10 Paint darks on the far right of the painting to contrast with the tree. The colours should merge with the wet background. Push the paint around quite vigorously using a worn brush. Add lemon yellow. Use viridian and cobalt blue for the cool green at the base of the left-hand trees. Paint the bank on the left with lemon yellow and Naples yellow. Add warmth using raw sienna and burnt sienna.

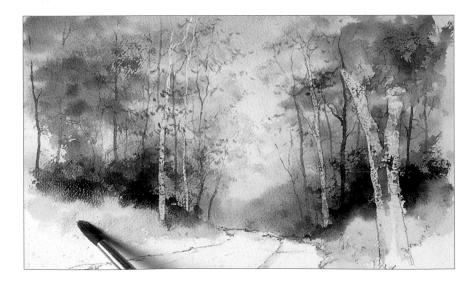

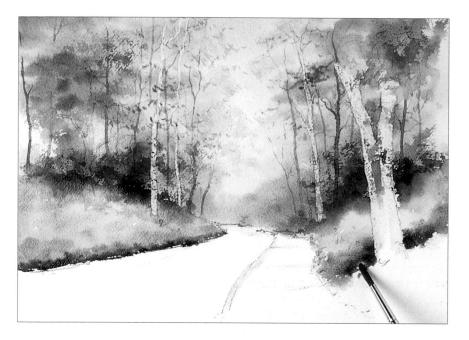

11 On the left of the painting, paint the green mixed from cobalt blue and aureolin down to the canal's edge. Add lemon yellow for brightness and Naples yellow for creamy highlights. While the painting is still wet, paint the darks by the water's edge using the mixture of viridian, French ultramarine and burnt sienna. Brown this area using burnt sienna to suggest the exposed soil on the bank under the trees. On the righthand bank, paint raw and burnt sienna for warmth and add lemon yellow and then dark green down to the right-hand bank. Add darks round the tree trunk, and cobalt blue mixed with aureolin around the base of the trunk.

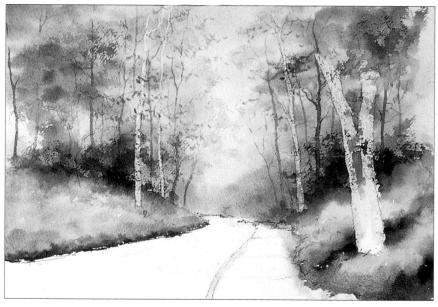

12 Add a hint of cobalt blue and rose madder at the edge of the path, and burnt sienna for a touch of warmth.

Allow the painting to dry.

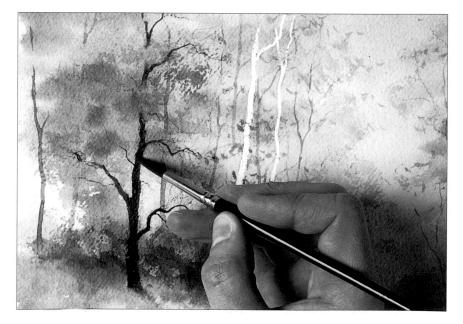

TIP

When painting from a complex photograph like this, use it as inspiration but do not copy it slavishly.

13 Rub the masking fluid off the trees. Mix burnt sienna and cobalt blue to make brown, warm it with a touch of rose madder and paint the dark tree on the left. This should be a stronger mix than used for the trees behind it to make it appear further forward. Leave some gaps in the top of the trunk so it appears as though you are glimpsing it through the foliage.

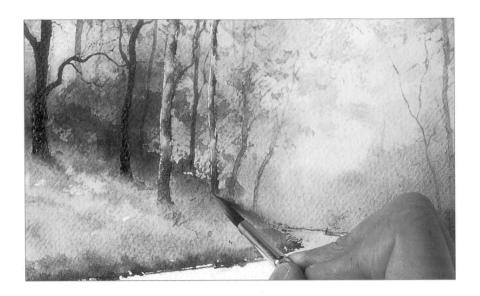

14 Fill in the trunks of some of the trees quite darkly, and water the mix for a fainter look at the top. Strengthen the tone where the trees are nearer the foreground. To avoid trees looking as though they are standing on the ground rather than growing out of it, soften the area around the base of the trunks. Take a wash of Naples yellow and rose madder (the colour which gave the sky its glow) and fill in the lighter trunk. Paint some brown to shade the left-hand side.

TIP
With a subject like this it is important to keep reminding yourself which direction the light is coming from.

15 Use more dark brown and a rigger brush to put in the very fine branchwork at the top of the tree. This makes sense of the foliage you have already painted by connecting it to the tree.

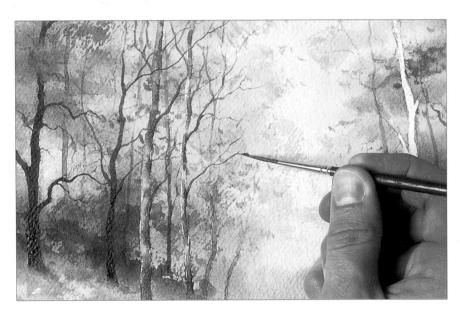

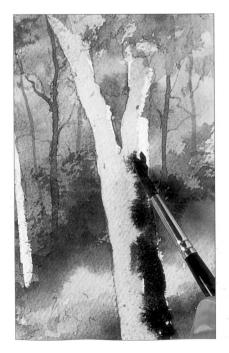

16 Paint the right-hand trees in the same way, wet in wet. Paint pink on to the lighter trees, using Naples yellow and rose madder. Add cobalt blue and rose madder. Drop in burnt sienna for the base of the tree, and burnt sienna and French ultramarine with a little rose madder to shade the right-hand side.

17 Continue with the right-hand tree. Use the Rough paper and a bit of dry brush work to create the effect of bark. Soften the trunk with clear water and create texture by dabbing with a piece of kitchen towel.

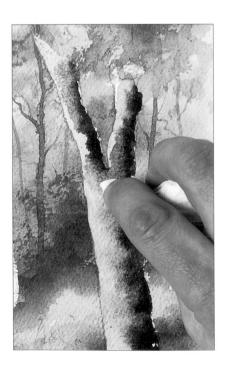

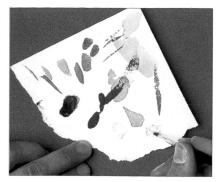

18 On scrap paper mix white gouache with lemon yellow and white gouache with viridian. Do not mix these in the palette, or for several weeks afterwards you may find that the colours you mix take on a chalky appearance.

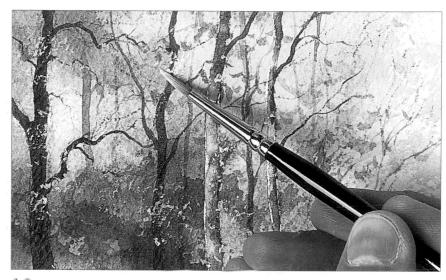

19 Use the gouache mixes to highlight the foliage with small marks interrupting the view of the trunks.

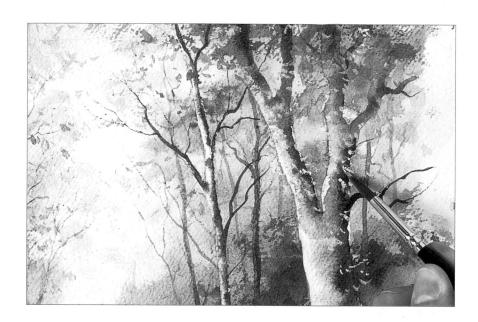

Work on the canopy of the right-hand tree using a no. 12 brush and scumbling with a dry mix of viridian, French ultramarine and burnt sienna. Add darker leaves in shadow. Use dry brush work at the top to indicate foliage and frame the painting, using aureolin and cobalt blue. Use the same colour lower down among the brighter leaves.

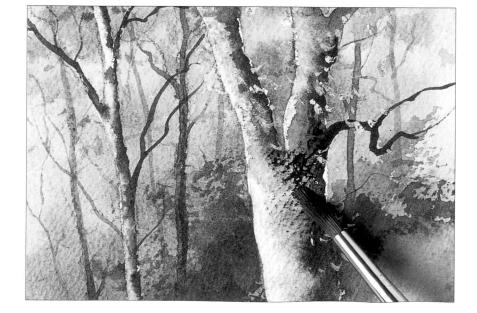

21 Create more texture on the bark if necessary, using burnt sienna and cobalt blue with a little rose madder and dry brush work. Add a hint of warmth by painting on burnt sienna in the same way.

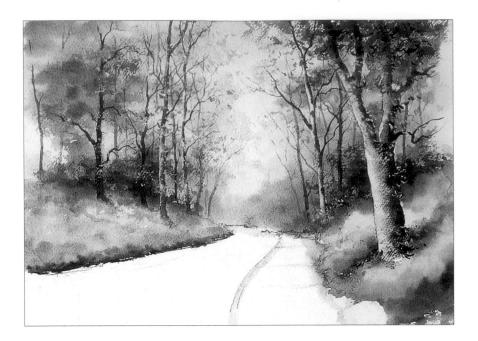

22 Make very dark marks on the bark using burnt sienna and French ultramarine. Touch in foliage around the base of the trunk.

Most of the colours you have already used are needed for the reflections. Rub off the masking fluid at the top of the canal bend and neaten the edges. Wet the whole water area, leaving a fine gap along the left-hand edge dry to separate the canal from the bank. Drop in reflection colours: yellow, purple, pink at the bottom from the sky, green in the middle. Reflect the brown darks from the bank, working quickly while the painting is wet. Add viridian and browns at the top right-hand edge of the canal. Add lemon yellow for brightness. Take a damp 1cm (½in) flat brush and drag down the reflection colours in vertical strokes. You have to work rapidly on this stage as the dragging down effect will not work on dry paper.

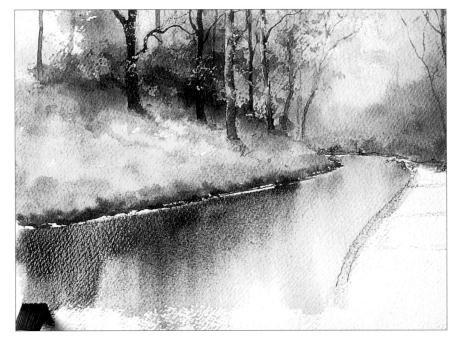

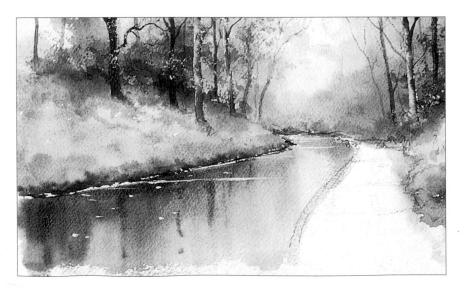

24 Work on the details of the water. Using a no. 4 brush, darken the water's edge with a very dark brown and dampen it in with green. Tint the white line at the water's edge using a little raw sienna. Use white gouache straight from the tube to paint horizontal streaks on the water's surface. Mix Indian yellow with white gouache to paint the leaves floating on the surface. Touch in dark reflections of tree branches.

25 Mix a pink colour again using Naples yellow and rose madder, for the path. Rub off the masking fluid. Wet the area and drop in the pink over the entire path area. Mix the sky colours cobalt blue and rose madder and use this mix to indicate shadows.

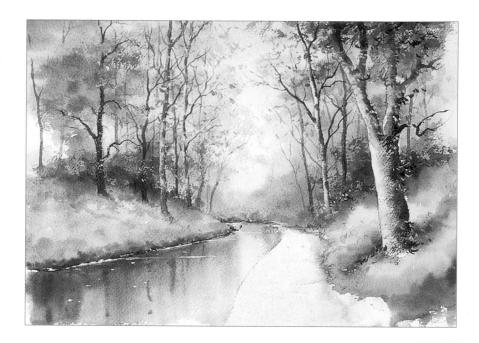

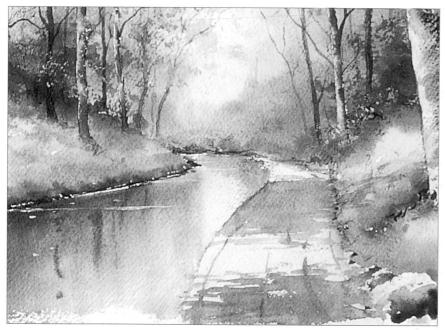

26 Paint more shadows with the same sky colour with a little burnt sienna added. Soften them with a damp brush. Paint dappled shadows in the foreground using a no. 12 brush. Use burnt sienna and French ultramarine to shadow the dark side of the stone on the right-hand side.

27 Scumble darks at the right-hand edge of the path and in the foreground. After standing back to consider the result, I decided to add contrast between the canal and the path by darkening the water with brown and green right in the foreground.

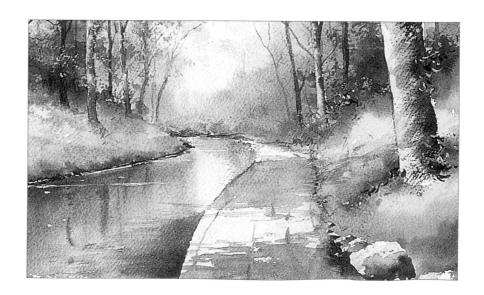

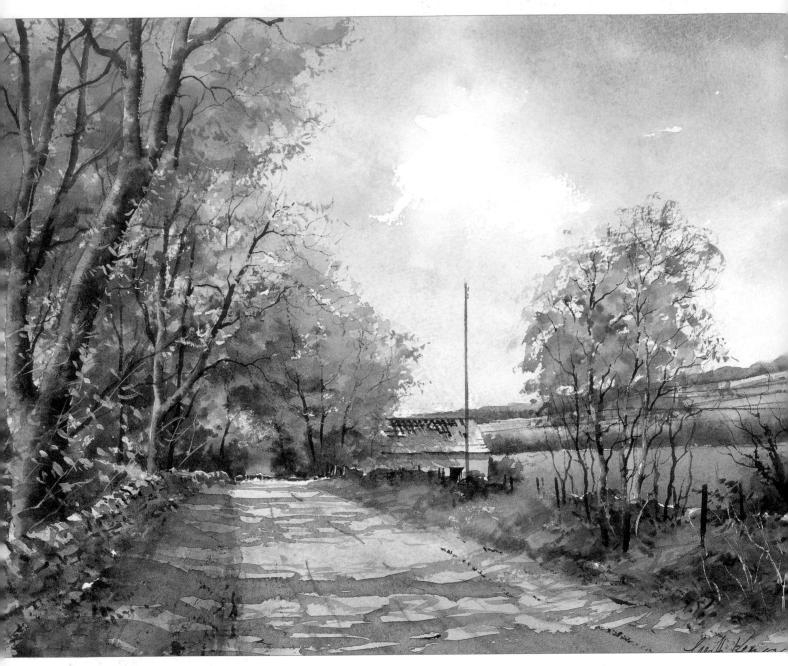

Autumn on Darley Hillside

355 x 280mm (14 x 11in)

When you get a crisp, bright light on an autumn day, you don't have to go far to find a subject. This is another example of how to simplify a mass of foliage by not trying to copy it exactly. Again here I have used a bit of white gouache with a touch of colour to pick out a few highlights like leaves against the darks of the tree trunks and masses of foliage. Note also how the shadows, indicated in a warm purple, help to describe the slope of the verges and the flatness of the road, while at the same time emphasising the perspective. These shadows are also suggested on the roof of the old barn in the middle distance, helping to reinforce the direction of the light.

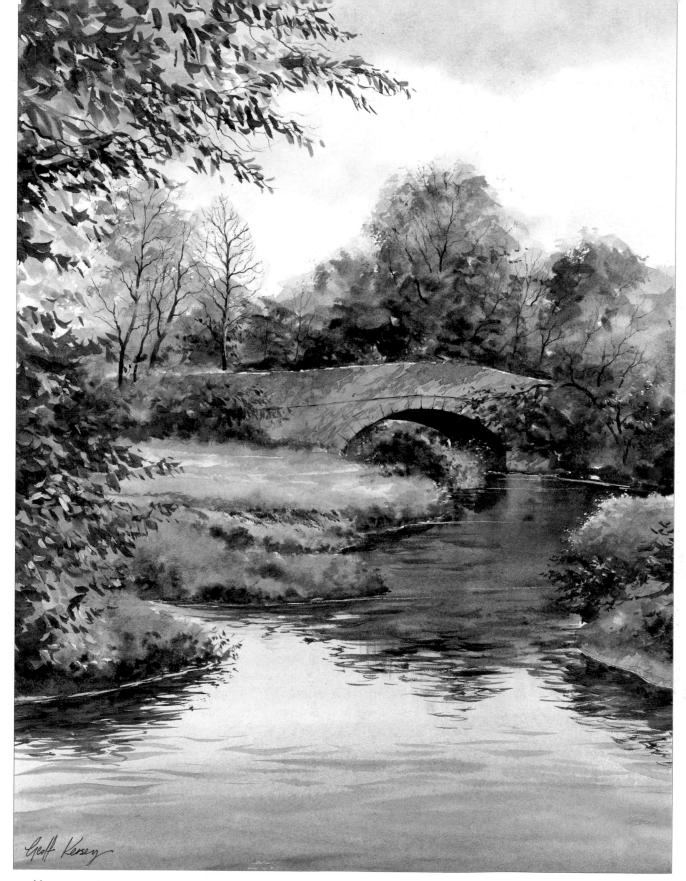

Packhorse Bridge, Sutton on the Hill

508 x 406mm (20 x 16in)

In this scene I have used two methods to depict the reflections in the river. Those nearest to the bridge have been created using the same method as the main painting in this chapter, i.e. pulling down the colour with a flat brush to make the washes vertical. As the water gets nearer to the viewer, the gentle ripples disturbing the surface are more noticeable, so I have created a more broken look to the reflections. Note how the darker colour at the top of the sky is echoed in the water in the foreground, almost framing the scene. The contrast between the red coloured bridge and the rich greens give this painting good visual impact.

Farm Buildings

I particularly enjoy this composition and have painted it many times. The farmer does not share my enthusiasm for the tumbledown old barn, looking forward to the day when it will be repaired, so I have made sure I have a collection of photographs and sketches.

Notice how you get just a glimpse of the distant woods on the slope, indicated in a soft violet that matches the sky. The shadows help the perspective on the road as well as adding warmth. Shadows should always be laid in thin transparent glazes, enabling the viewer to see a hint of the earlier washes underneath.

Here I have taken three portrait format photographs and taped them together, providing me with quite a large image showing plenty of detail. I have a box overflowing with these, and although with all the lines down them and bits of tape holding them together they do not look very attractive, they are packed with reference and information.

I decided to include quite a bit of detail in this painting, so I didn't really need to simplify the scene in the sketch.

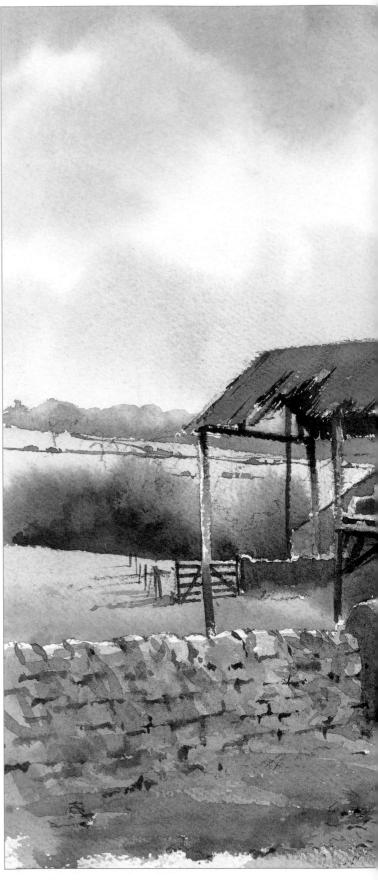

The finished painting

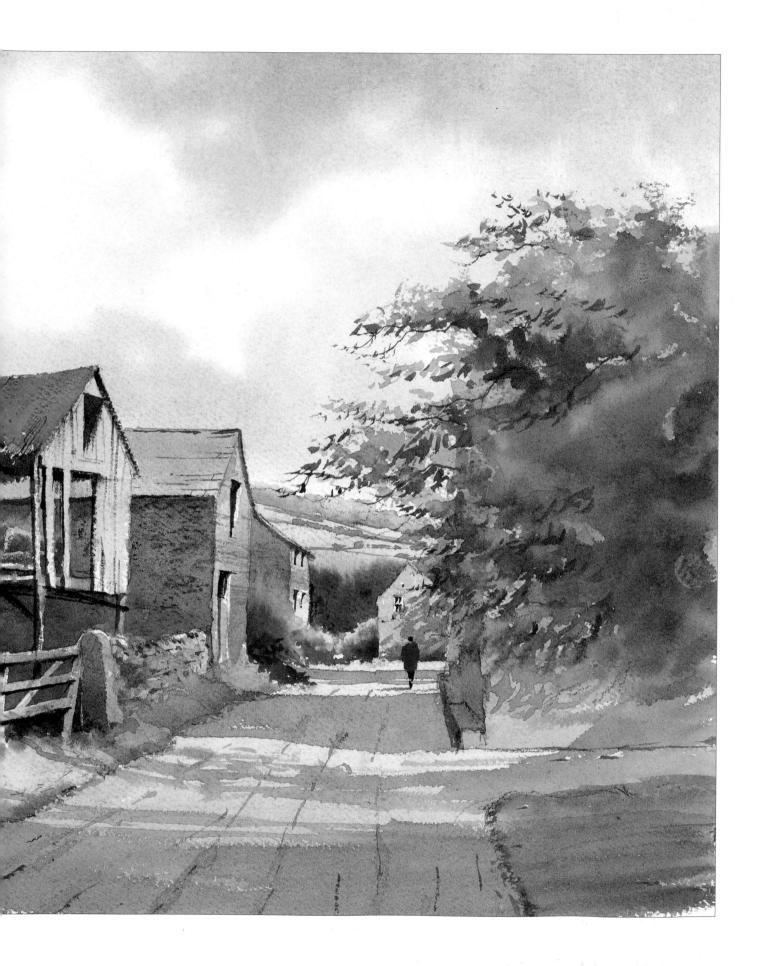

You WILL NEED

Rough paper, 460 x 350mm

 $(18 \times 13^{3/4}in)$

Masking fluid

Naples yellow

Indian yellow

Cobalt blue

Rose madder

Burnt sienna

Aureolin

Raw sienna

Viridian

Burnt umber

Cerulean blue

Cobalt violet

French ultramarine

Cadmium red

White gouache

Lemon yellow

Old paintbrush

2.5cm (1in) flat brush

Large filbert wash brush

Round brushes: no. 6, no. 10,

no. 12, no. 4

Kitchen towel

Tracing paper

Craft knife

Sponge

1 Sketch the scene and apply masking fluid to the tops of the roofs, the beams of the open-sided building, the gateposts and the top of the foreground wall.

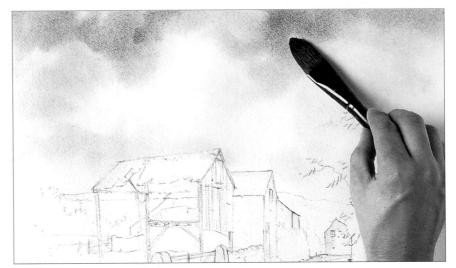

2 Mix the sky colours: Naples yellow and Indian yellow; cobalt blue and rose madder; cobalt blue, rose madder and a little burnt sienna. Wet the background using a 2.5cm (1in) flat brush, down to the masking fluid. Use a large filbert wash brush to paint a yellow glow at the bottom of the sky. Wash the brush and then add cobalt blue and rose madder at the top of the sky. Finally add cobalt blue, rose madder and burnt sienna to suggest a hint of cloud. Allow the painting to dry.

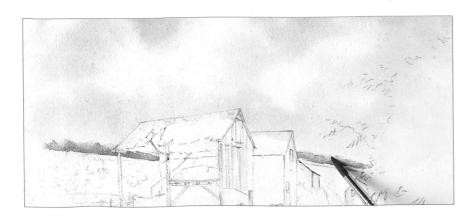

3 Use a wash of cobalt blue and rose madder for the distant bushes and trees. Soften their tops using a damp brush. Add a little burnt sienna to the mix to paint a darker colour at the base. Take these colours through to the other side of the barn.

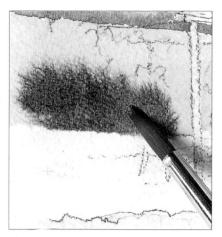

4 Mix aureolin and cobalt blue to make a green, brushing this in to indicate the land on the left. Paint the bush on the left by dropping in aureolin and cobalt blue mixed with burnt sienna. Continuing to paint wet into wet, drop in viridian and burnt sienna, which will create a dark to contrast with the top of the wall.

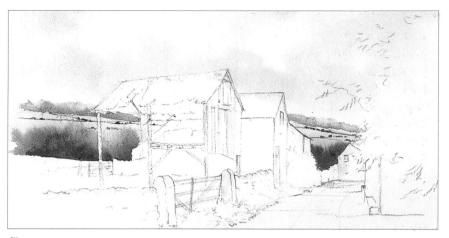

5 Continue with the same effects on the right of the painting, dropping in a touch of lemon yellow, then allow it to dry. Take a no. 6 brush and a mix of burnt sienna and cobalt blue and paint a suggestion of dry stone walls and hedges across the fields in the distance.

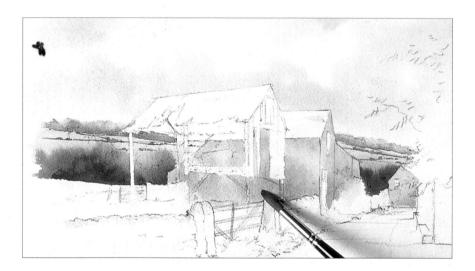

6 Remove all the masking fluid from the main building, but leave it on top of the wall. Apply a mixture of raw sienna and Naples yellow on to the building at the end of the lane, leaving spaces for windows. Paint the buildings on the left in the same way and soften the colour at the bottom. Painting wet in wet, add a pink mix of Naples yellow and rose madder over all the buildings, and drop in patches of burnt umber.

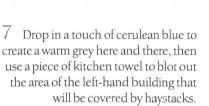

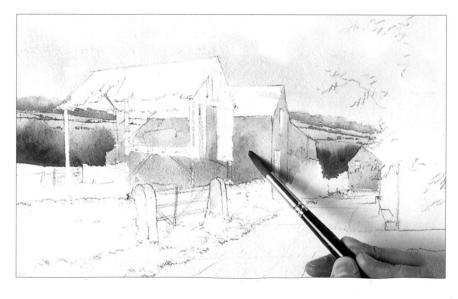

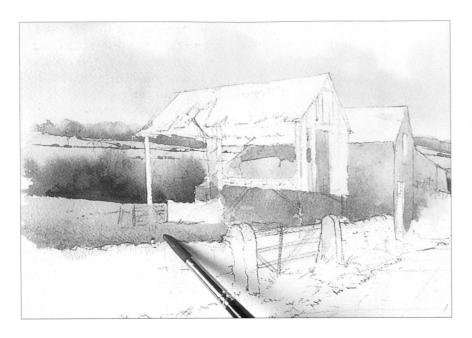

8 Add a mixture of cobalt blue, rose madder and burnt sienna for the darker colour in the stonework, and allow it to dry. Paint the light in the field on the left using Naples yellow and Indian yellow and a no. 10 brush, then add green mixed from aureolin and cobalt blue nearer to the top of the wall.

9 Drop the same green in behind the gate and soften it into the background. Mix a rich brown from burnt sienna and cobalt blue and paint this below the barn. Mix an even darker brown from burnt sienna and French ultramarine for areas of deep shadow.

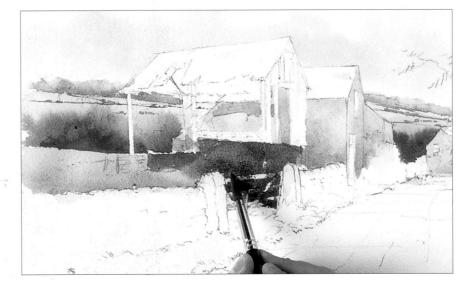

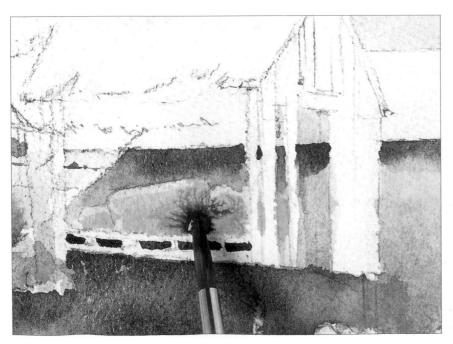

10 Use the same dark brown under the guttering of the middle building. Paint raw sienna for the haystacks, leaving the white of the paper for the light catching the tops. Use cobalt blue and rose madder for the shadow on the haystacks.

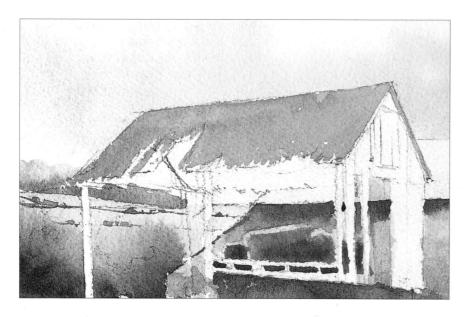

11 Paint the rusty roof of the barn using Indian yellow and cadmium red. Exaggerate the orange as it creates a good contrast with the sky. Leave a few very small patches of white paper to suggest the ragged, broken edge of the roof.

12 Drop in burnt sienna to deepen the colour of the rusty roof, then add cobalt blue, and rose madder to darken it slightly. This should tone down the bright orange of the roof, but don't overdo it or you will lose that all important feel of the sunlight catching the rusty roof.

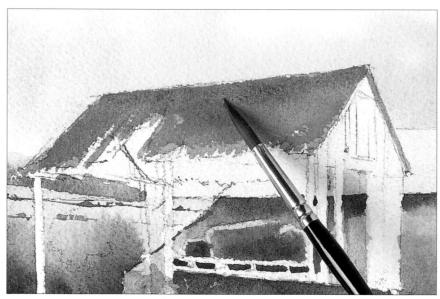

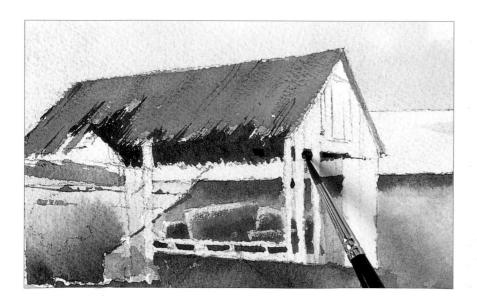

13 Mix white gouache and Naples yellow on a piece of scrap paper and use dry brush work to add a bit of detail to the haystacks. Mix a rich dark brown using burnt sienna and French ultramarine and paint the inside of the barn roof using a no. 12 brush. Fill in the shapes of the broken roof and very gently add a few fine lines to suggest the corrugation using a no. 4 brush.

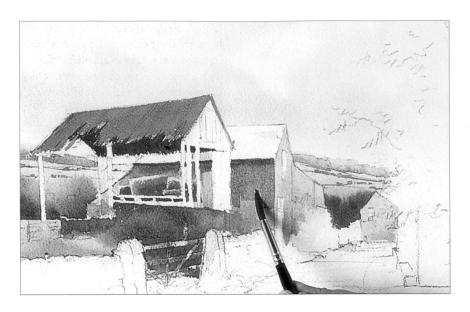

14 Wash the shadowed side of the barn with a thin glaze of cobalt blue and rose madder. Add burnt sienna to warm the bottom of the shadow for reflected light. Make sure this wash is not too strong so the transparency of the watercolour means that you can see through the shadow to the layers of wash underneath. Continue painting the shadow colours over the whole side of the building.

15 Intensify the shadows at the edges, against the light, to create contrast and form. Drop lemon yellow into the shadow of the second building from the right to suggest some foliage. Mix viridian, French ultramarine and burnt sienna to make green and drop this in with a no. 6 brush, allowing it to wander into the other colours to accentuate this bush shape.

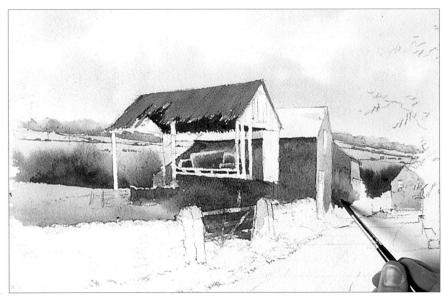

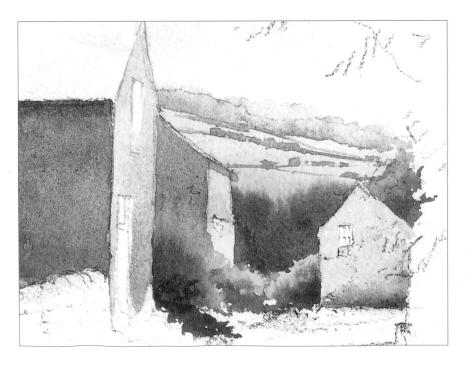

16 Paint a bush next to the cottage at the end of the lane in the same way: the darkness will help to pick out the lighter wall of the cottage. Darken the cottage near the ground by floating in a little shadow colour and allow to dry.

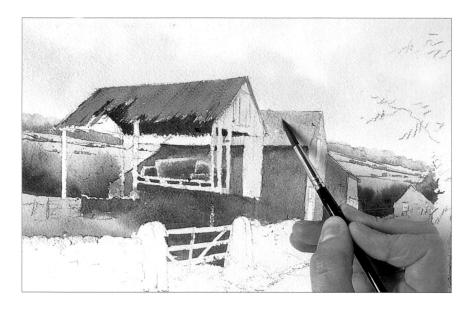

 $17\,$ Rub the masking fluid off the barn and the gate. Paint a pale wash on the barn's woodwork of cerulean blue with a hint of green mixed from aureolin and cobalt blue. Paint the middle roof with the same green. Add a touch of cobalt blue and rose madder to hint that sky colours are reflected in the roof.

18 Mix a dark brown from burnt sienna and French ultramarine and use a no. 4 brush to paint the finer details on the barn. Use dry brush work and the same colour to paint the dark window-like hole at the top.

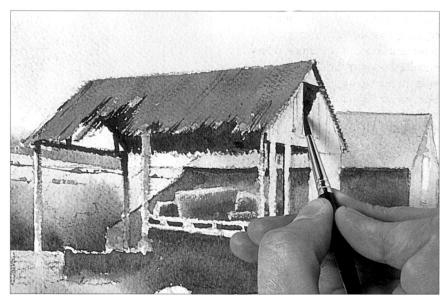

TIP Fine details are most effective when 'drawn' with quick strokes of a fine brush.

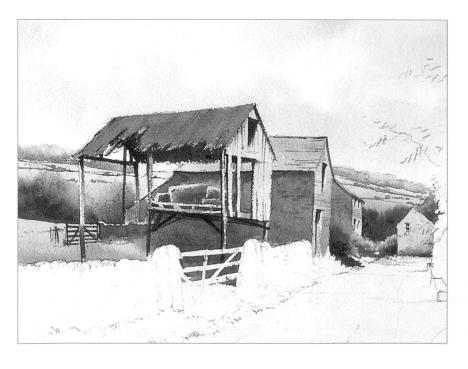

19 Continue painting details with the point of a no. 4 brush. Add shadows to the barn, leaving the uprights free of shadow where the sun shines. Paint in the distant five bar gate on the left, supports under the hay loft and suggestions of slates on the middle roof. Paint the front door of the middle building with a drop of cerulean blue and then dark brown for the interior. Use the same dark brown to paint the top window and suggest the windows of the distant cottage.

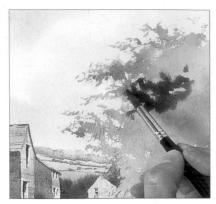

20 Paint the tree on the right with a glimpse of wall showing beneath it. Wash on the stone colour first, mixed from raw sienna, Naples yellow and Indian yellow. Then drop in the green, mixed from aureolin and cobalt blue. Use dry brush work to suggest foliage, and continue in this way with a darker green on top.

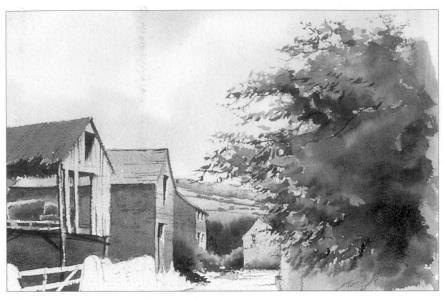

21 Mix a dark green from viridian, French ultramarine and burnt sienna and paint this on wet in wet. Use a no. 6 brush and aureolin mixed with cobalt blue to suggest leaves at the ends of the branches.

22 Paint the gate with a mix of cerulean blue, Naples yellow and Indian yellow, leaving a few glimpses of white paper to give the timber a washed out look. Allow this to dry and then add a touch of detailing using burnt sienna mixed with French ultramarine.

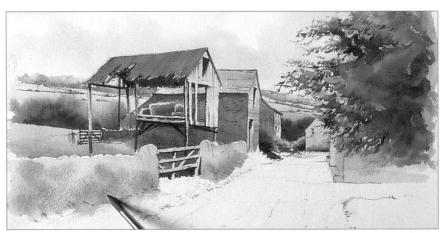

23 Rub off the masking fluid from the wall. Now paint the wall and the grass verges together so that they soften into one another. Paint on a wash of raw sienna, leaving a glimpse of white at the top, and drop in green mixed from aureolin and cobalt blue, and then burnt sienna.

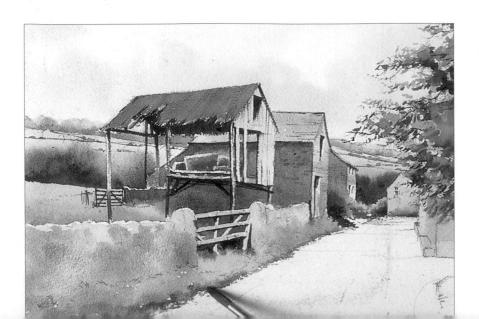

While the wall is still wet drop in some of the sky colour, cobalt blue and rose madder. Paint the grass using lemon yellow and green. Add more lemon yellow to make tufts, then raw sienna for warmth. Use the point of the brush to suggest the edge where the grass meets the lane. Keep this line irregular or it will appear as though the grass has been trimmed. Towards the foreground add dark green mixed from viridian, French ultramarine and burnt sienna for the roadside tufts of grass.

25 Dab the stone wall just before it dries with a piece of kitchen towel to create texture.

26 Work on the shape of the wall by adding shadow mixed from cobalt blue and rose madder. Shadow the gateposts and add a touch of burnt sienna to represent reflected colour. Use the point of a no. 12 brush to suggest the shape of stones and crevices. Vary the pressure you apply to create an irregular look to the crevices.

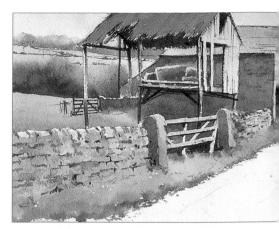

27 Continue working on the wall. Use cobalt blue and rose madder to darken some of the stones, and dry brush work to create texture. Paint the deepest crevices using burnt sienna and French ultramarine. Remember that the details should all be smaller when they are further away. Darken the bottom of the five bar gate using the same dark brown, and soften the bottom edge.

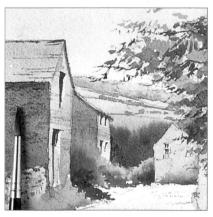

28 Use dry brush work to paint the perspective lines of texture on the middle building.

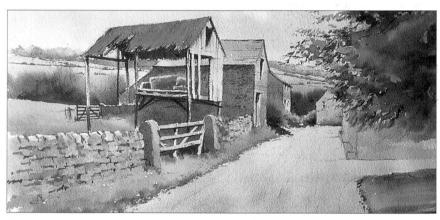

29 Mix two washes for the path: Naples yellow with Indian yellow and cobalt blue with rose madder, reflected from the sky. Wash in the yellow colour from the top. Clean the brush and brush in the shadow wash on top. Wash from side to side with horizontal strokes to accentuate the flatness of the road. Allow the painting to dry.

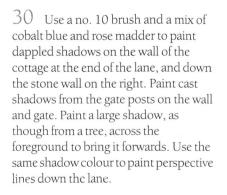

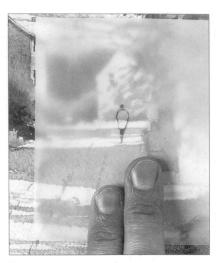

31 To place a figure, draw a simplified, tapering shape on a piece of tracing paper and try positioning it to see how it looks in the painting.

32 When you are satisfied with the placing of the figure, place the tracing paper on a cutting mat and cut out the shape of the torso using a craft knife. Place the tracing paper on the painting again and using it as a stencil, dab over it with a damp sponge to remove pigment.

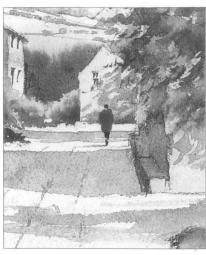

33 Paint the figure in cadmium red, with burnt sienna and French ultramarine for the trousers. The feet should come to a point for a walking figure, or it will look as though the person is stationary. Add more dark for the head, leaving a gap for the collar, otherwise the figure may look hunched.

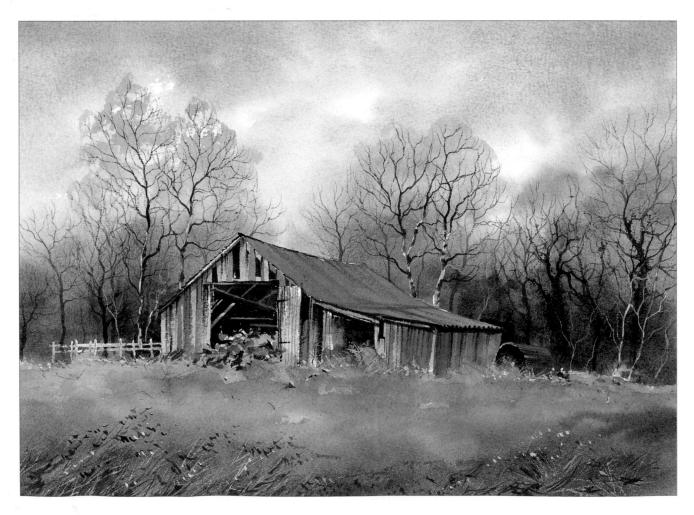

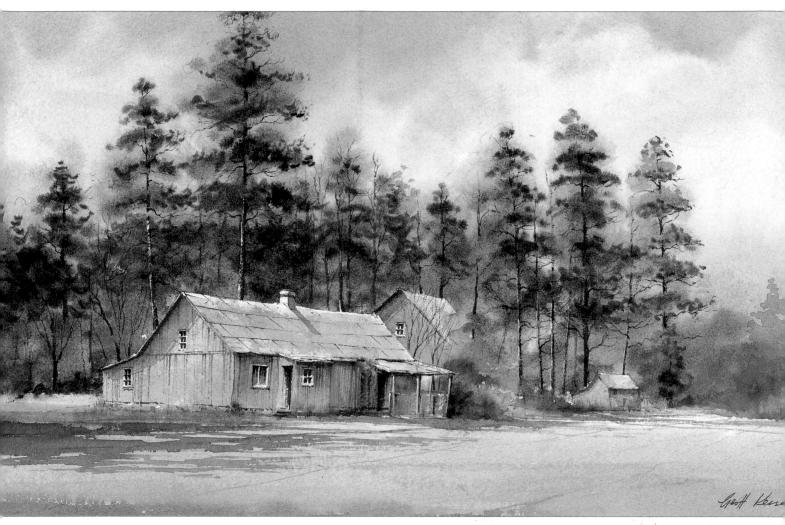

Homestead, Estonia

457 x 305mm (18 x 12in)

I've never been to Estonia, in fact I don't even know where it is, but one of my students brought along a photograph of this scene she had taken on holiday and I asked if I could use it. What appealed to me was the soft light and the tumbledown nature of the buildings, perfectly framed by the tall trees behind them.

Opposite Old Woodshed, Sandringham Estate

 $318 \times 230 mm \ (12\frac{1}{2} \times 9in)$

I discovered this tumbledown old wood store, just over the fence from a cottage I stay in when teaching at the West Norfolk Art Centre. When I spoke enthusiastically about it to the man who owns the cottage, I think I probably reinforced the notion that artists are a bit eccentric. I have exaggerated the warm colours, using plenty of burnt sienna and Indian yellow to try to create a soft glow. It is good fun to exaggerate the colours sometimes rather than trying to analyse and reproduce them exactly as they are. Of course you could come unstuck and overdo it but take the risk – it's only a piece of paper.

Index

atmosphere 22, 27, 70

background 46, 48, 68, 74, 75, 86, 88 beaches 4, 14, 40, 70 boats 4, 11, 13, 21, 41, 62–71 brushes filbert 10, 24, 27, 32, 44, 54, 64, 86 flat 10, 24, 25, 44, 54, 58, 74, 75, 80, 83, 86 rigger 10, 44, 47, 48, 54, 59, 74, 78 round 10, 26, 29, 32, 44, 46, 47, 48, 49, 54, 64, 69, 74, 75, 86 wash 10, 26, 27, 32, 44, 54, 64, 86

composition 4, 12, 21, 42, 52, 62, 84 focal point 4, 52, 61, 66 craft knife 11, 48, 86, 94 blade 11, 54, 58

detail 17, 22, 23, 26, 50, 62, 65, 67, 68, 74, 80, 84, 91, 92, 93 distance 6, 15, 16, 21, 22, 23, 25, 33, 34, 42, 46, 47, 51, 52, 55, 56, 64, 65, 66, 82, 87 dry brush 8, 10, 46, 56, 57, 75, 76, 78, 79, 89, 91, 92, 93 dry stone wall 6, 23, 34, 38, 46, 47, 87

fields 28, 34, 38 foliage 14, 23, 36, 46, 72, 75, 76, 77, 78, 79, 80, 82, 90, 92 foreground 4, 15, 16, 22, 23, 34, 38, 39, 44, 48, 49, 58, 59, 62, 66, 68, 78, 81, 83, 86, 93

glaze 4, 17, 28, 29, 84, 90

highlight 32, 67, 68, 77, 79, 82 hills 19, 22, 23, 30, 32, 33, 36, 42, 46, 54, 55, 56, 57, 61, 82, 83

masking fluid 11, 32, 34, 37, 38, 44, 46, 48, 49, 54, 58, 64, 65, 66, 67, 74, 77, 80, 81, 86, 87, 91, 92 mountains 22, 61

painting board 8, 27, 37, 50
palette 9, 11, 14, 26, 50, 71, 79
paper
Rough 8, 32, 44, 46, 54, 56, 64, 74, 78, 86
stretching 8, 11
path 4, 39, 40, 42, 47, 49, 52, 74, 77, 81, 93
perspective, aerial 6, 16, 22–23, 49, 51, 52, 54, 64, 66
perspective, linear 4, 6, 18–21, 22, 23, 38, 49, 52
eye level 18, 19, 23, 38
vanishing point 18, 19
photograph 30, 62, 68, 69, 75, 77, 84

reflections 60, 66, 72, 80, 83 river 52, 54, 58 rock 49, 54, 59, 61

sand 16, 40, 66, 67, 68, 69 scumbling 48, 79, 81 sea 19, 66 shadows 4, 14, 16, 17, 24, 25, 35, 39, 47, 49, 55, 60, 61, 64, 65, 67, 68, 69, 79, 81, 82, 84, 88, 90, 91, 93 sketch 10, 12, 13, 15, 30, 42, 44, 52, 62, 64, 70, 72, 84, 86 tonal value 10, 12, 30 skies 4, 6, 10, 14, 16, 17, 19, 21, 22, 23, 24–29, 32, 33, 37, 38, 39, 42, 46, 49, 54, 55, 58, 64, 66, 67, 70, 74, 78, 80, 81, 83, 84, 86, 89, 91, 92, 93 clouds 14, 22, 25, 26, 29, 55, 64, 66, 86 snow 4, 16, 28, 42–51, 56 stone 54, 58, 60, 61, 81, 92, 93

tone 10, 12, 13, 15, 22, 23, 69 tree trunk 6, 47, 48, 74, 76, 77, 79, 80, 82

washes 10, 11, 16, 22, 23, 24, 25, 26, 27, 28, 29, 32, 33, 47, 50, 51, 54, 58, 64, 65, 66, 67, 70, 72, 74, 76, 83, 84, 90, 91, 93 wet in wet 24, 26, 33, 37, 38, 45, 48, 49, 55, 57, 58, 64, 66, 72, 74, 78, 87, 92 wet on dry 46, 68 white gouache 6, 9, 13, 44, 50, 54, 56, 59, 64, 65, 68, 74, 79, 80, 82, 86, 89 woodland 4, 16, 42, 44 woods 4, 42, 51, 84

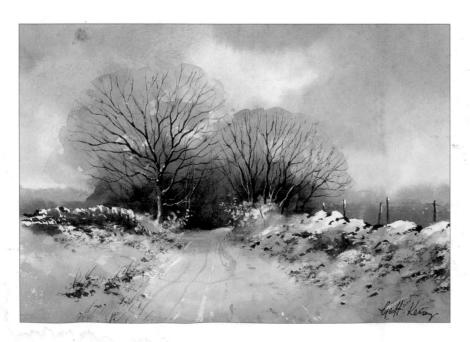

A Winter Walk

254 x 178mm (10 x 7in) Not every painting has to be a carefully considered, major work. This forty minute watercolour sketch makes up in spontaneity for what it lacks in detail.